KANE COUNTY
COUGARS

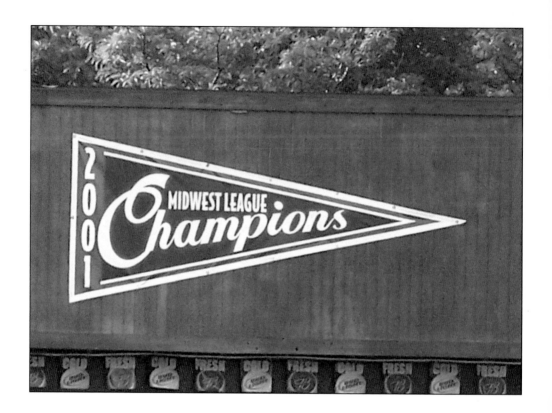

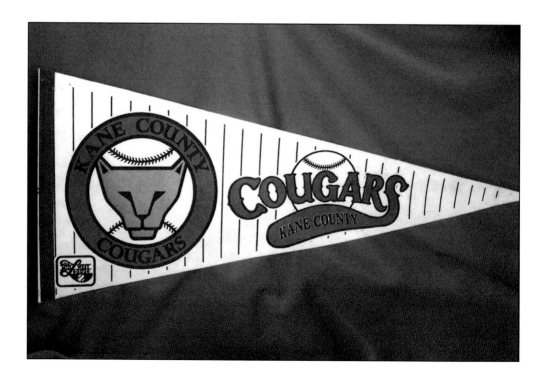

KANE COUNTY COUGARS

David Malamut

ARCADIA
PUBLISHING

Published by Arcadia Publishing
Charleston, South Carolina

Printed in the United States of America

Library of Congress Catalog Card Number: Applied For

For all general information contact Arcadia Publishing at:
Telephone 843-853-2070
Fax 843-853-0044
E-mail sales@arcadiapublishing.com
For customer service and orders:
Toll-Free 1-888-313-2665

Visit us on the internet at www.arcadiapublishing.com

CONTENTS

ACKNOWLEDGMENTS

Thank you to every one who has helped put together this project. I have to say special thanks to my father who has advise me on the book and helped out with some of the pictures, and my mother who has provided all of the support and encouragement one could ask for. Thanks to Bob Yahr and Harriet Malamut for helping me with editing the text.

For the pictures, a big thank you to Pam Rasmussen, Bob Yahr, Dan McQuade, Mark Cordes, and Dale and LuAnn Klein for letting me use some of the photos that they have taken over the years. Thanks to Dennis Buck and the staff at the Aurora Historical Society for their help with the history of baseball in Aurora. Thanks to the Kane County Cougars, especially Kari Kuefler, Director of Public Relations, for coming through in the clutch with some last minute images.

Thank you to my editor Jeff Ruetsche at Arcadia Publishing for all of his help in this project.

To view any more of my work please go to my website at http://malamut.net

INTRODUCTION

The minor leagues are filled with stories and history. Sometimes history is made by individual players, such as Joe DiMaggio's 61-game hitting streak with the San Francisco Seals of the Pacific Coast League in 1933; other times it is made by individual teams, such as the 1934 Los Angeles Angels, whose record of 137 wins and 50 losses place them as the best minor league team of all time, according to a recent survey by Minor League Baseball. Other times that history is made in individual games, such as the 33-inning game between Rochester and Pawtucket in 1981; or in the 1965 doubleheader when two Rocky Mount pitchers each threw a seven-inning no-hitter against Greensboro.

History has also been made by one team in the minors moving from one location to another. One of the most notable moves was when the Milwaukee Brewers of the American Association moved to Toledo in 1953, to accommodate the transfer of the major league Boston Braves to Milwaukee. That, like most other moves, involved teams moving to areas not having major league baseball. However, history was also made in 1991, when a minor league team did the unimaginable and moved into an area where there were already two existing major league franchises.

That team is the Kane County Cougars, who have just completed another good season both on the field and in the stands. They have drawn over a half million fans in each of the past four seasons. On the field they have made the playoffs in three of the last five years. In those years they won only one championship but have had many exciting games.

The Cougars moved to Geneva, a western suburb of Chicago, back in 1991, after the franchise had been in Wausau, Wisconsin, and not drawing many fans. In 1990, the Wausau Timber drew only 56,434. In 1991, the inaugural season for the Kane County Cougars, they drew 240,290. That is 183,856 more fans with the transfer of the franchise to the "burbs" of Chicago.

How could that move make that much of a difference in attendance? That much of a difference is what some teams draw in a whole season in the Midwest League. Well, in 1990, the Kane County Forest Preserve built what would later be known as Phillip B. Elfstrom Stadium to help draw the Cougars into Kane County.

New stadiums naturally produce a big increase in attendance. In some cases it's just a new stadium with a current franchise, but in others it's a new stadium in a new location. Is it because of the novelty of the team, or that everyone just wants to see some professional baseball in their town?

Elfstrom Stadium is only around 40 miles west of Chicago. In Chicago there are the Cubs and the White Sox, who routinely draw in excess of five million fans a year combined. With the Cougars never being affiliated with the Sox or the Cubs, they don't have fans coming out to see future Sox or Cubs players. That is, until their affiliates are playing in Kane County.

The Cougars have fielded plenty of top prospects over the years. From Alex Ochoa and Curtis Goodwin to Josh Beckett and Dontrelle Willis, baseball fans have seen a lot of talented kids play in Geneva. Sometimes it's just for a couple of weeks like Ryan Dempster or Alex Gonzalez, or sometimes we all get lucky and it's for the whole season, like with Charles Johnson.

The first few stars to come through Kane County were the "Old Roman" Charles Comiskey, and Casey Stengel, back in the nineteenth and the early twentieth century. There have been many more, right on through to Joe Blanton and Huston Street just recently.

In 2001, the Cougars got their only championship and have been to the playoffs regularly since 1999. They went from worst to first in their opening season of 1991, and have made it to the final game of the championship series, only too lose, twice.

The one thing that has always remained the same is that the Cougars have always had plenty of people in the stands. They have topped half a million fans for each of the past four seasons. They have been known to out-draw several major league teams head-to-head during July and August. Kane County has the Midwest League record for single-game attendance at 14,452. Fans keep coming to Elfstrom, not only to watch the ball game, but because the Cougars put on a great show between innings with contests and music. They do the usual minor league mascot race, but it's the other stuff that makes things fun.

ONE

Before There Were Cougars

The Cougars came to Geneva in 1991, but that wasn't the beginning of baseball in Kane County. There were local town teams going all the way back into the mid-1870s. Almost all of the Fox Valley towns had local teams. The best regarded was the 1875 Elgin team who had a star player named Charles Comiskey, the same Comiskey who would found the Chicago White Sox at the start of the twentieth century.

The first professional team in Aurora played in 1890, as a member of the Illinois-Iowa League. They played from 1890 to 1892. In 1890, they finished in fifth place. The team folded on June 16, 1891, with an 11-27 record. The Aurora Hoodoos, which came into existence after the Peoria Canaries moved to the area on May 31, 1892, took their place. The only problem was that they disbanded on July 5, with a combined 26-27 record.

The most important game was on April 20, 1891, when the Chicago White Stockings (Cubs) would play the Aurora team and lose to them, 4-3.

Not until 1910 would professional baseball creep back into the Fox Valley. The Aurora Islanders played in the Wisconsin-Illinois League. Unfortunately, they would end up that season in last place with a 43-81 record, 33 and a half games out of first place. That same year, Elgin had a team nicknamed the Kittens in the Northern Association. The team would finish in first place with a 37-20 record. The Kittens disband on July 11, eight days before the league disbanded. Fritz Maisel led the league in runs with 49. John Hopkins led the league in home runs with seven. One of the highlights of that year was a no-hitter thrown by a pitcher by the name of Boothby against Freeport in which the Kittens won the game, 7-2. Another no-hitter was thrown by a pitcher by the name of Wilson on May 30 against Freeport, again this time the Kittens won, 3-0.

The Aurora Blues came into existence in 1911 in the Wisconsin-Illinois League. They had a star center fielder by the name of Casey Stengel who led the league in hitting, with a .352 average, and in hits with 148. The Blues would finish seventh out of eight teams with a 55-67 record, 20 games behind Rockford. Season highlights were a no-hitter by LG Daniels on May 18, and another no-hitter, this time by a pitcher named Padden, both against Green Bay.

In the 1912 season the Blues finished next to last again, this time with a 54-80 record. In 1915, both Elgin and Aurora had teams in the Bi-State League. That would be the last of professional baseball in Kane County for over 70 years.

Late in 1985, a proposal was brought up to the Forest Preserve District and County Board in Kane County to build a minor league baseball stadium. In 1987, it looked good to have a new stadium built, as the Midwest League had awarded an expansion franchise to Kane County. It would've started play in 1987 but was held back until 1988 because the other expansion franchise in South Bend, Indiana, was having some delays in the construction of what would eventually become Stanley Coveleski Regional.

The stadium deal in Kane County fell through for the moment and the other expansion franchise would go to Rockford. It would be another two years before the Cougars officially came into existence and three years before they played their first game in Kane County.

Meanwhile, the Wausau Timbers who were playing in the Midwest League had been having attendance problems and were looking to be moved. In 1990, the team was sold to a group of investors who would move the team to the suburbs of Chicago the following year.

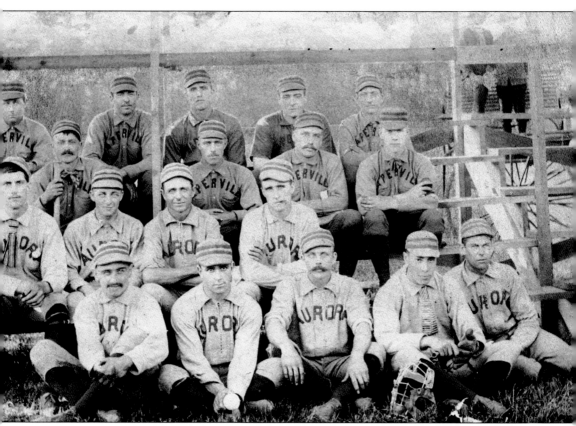

In 1886, the Aurora town team played a game against a team from the town of Naperville. In those days almost all of the towns in the area had teams of locals that played against each other. (Photo courtesy Aurora Historical Society, Aurora, Illinois.)

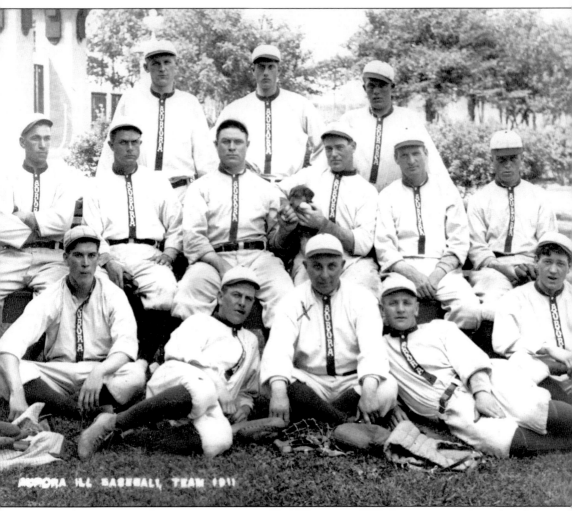

The 1911 Aurora Blues had a future member of the Baseball Hall of Fame. To the right of the manager, who is marked with an "X," is Casey Stengel. Stengel was elected by the veterans committee in 1966 to the Baseball Hall of Fame in Cooperstown, New York, as a manager. In 1911, he led the league in average and hits. He hit .352 that season with 148 hits in 121 games. Casey hit four homers, along with 23 doubles and six triples. In his major league career, which spanned from 1912 to 1925, he hit .284 in 1,277 games. He scored 575 runs and had 1,219 career hits, including 60 homers, 182 doubles, and 89 triples. As a manager from 1934 to 1965, he won 1,905 games and lost 1,842. He is most remembered for managing the New York Yankees from 1949 to 1960. In that time span he won 10 pennants and seven world series. He is the only manager to manage in five consecutive World Series. (Photo courtesy Aurora Historical Society, Aurora, Illinois.)

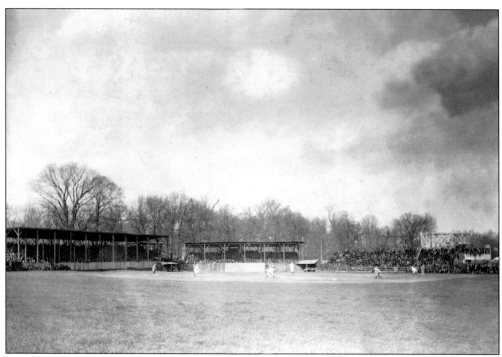

Fox River Park in Aurora was the site of many ballgames in the early 1900s. (Courtesy Aurora Historical Society, Aurora, Illinois.)

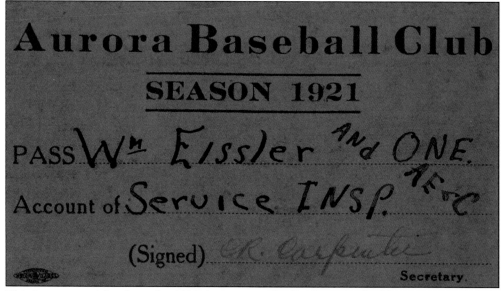

This is a season ticket from the 1921 Aurora team for Fox River Park. (Photo courtesy Aurora Historical Society, Aurora, Illinois.)

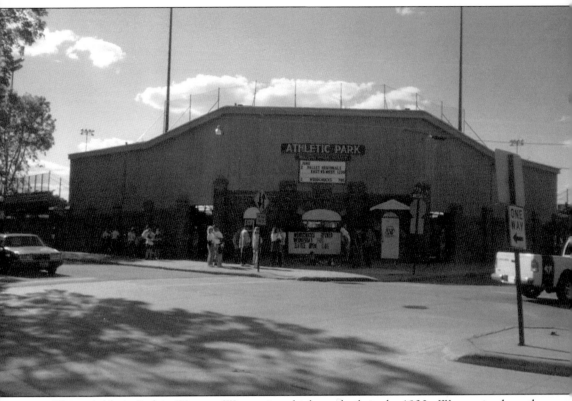

This is Athletic Park in Wausau, Wisconsin, which was built in the 1930s. Wausau is where the Cougars franchise played before its move down to Geneva. The year before the move they had Manny Alexander playing the infield. That year also saw future Cougars like Bo Davis, Steve DiMarco, Steve Godin, Aman Hicks, TR Lewis, Brent Miller. Jim Roso, Keith Schmidt, Brad Tyler, and Greg Zaun. The pitchers that played there that year were Matt Anderson, James Dedrick, Tom Martin, Juan Mercedes, Dave Paveloff, Brad Pennington, Tom Taylor, and Todd Unrein. (Photo by Bob Yahr.)

Currently, Athletic Park is the home of the Wisconsin Woodchucks of the college summer league. Unlike the regular college games, which are played with the aluminum bat, this league uses wood bats just like the pros. It is a good warm-up for prospective college kids who want to move on to the next level to learn how to hit like they do in the big leagues. (Photo by Bob Yahr.)

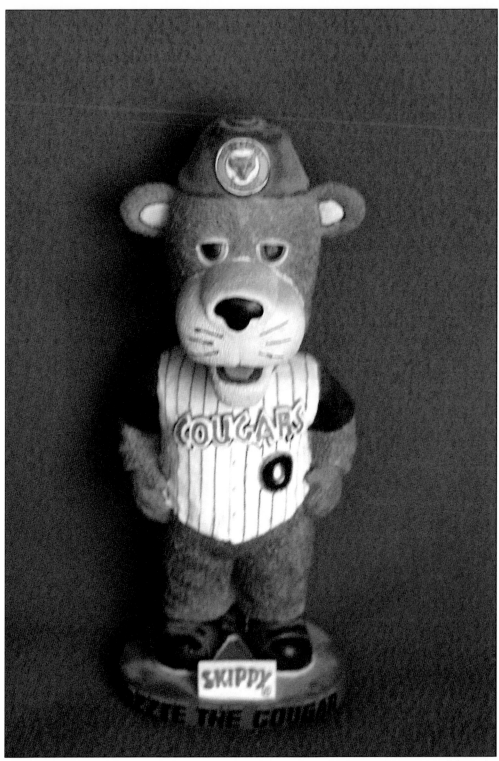

Ozzie the Cougar, seen here in the popular bobblehead form, is the team's mascot. (Photo by Alan Malamut.)

Two

1991–1992

The Cougars moved to the burbs of Chicagoland and played their first game on April 12, 1991. In that game they beat the South Bend White Sox, 8-0. The next game was the first game at Phillip B. Elfstrom stadium, in those days called Kane County Events Center. In that game they lost to South Bend, 13-0. The Cougars would finish the first half of the year in last place with a 26-40 record, twelve games behind first-place Madison.

The first pitch thrown by a Cougars was by Rob Blumberg, and the first win went to future Cub pitcher Joe Borowski. Former White Sox pitcher Jason Bere took the loss. Keith Schmidt hit the first ever Cougar homer. As for the first home game, Tom Martin threw out the first Cougar pitch at a home game; he would also take the loss in that game. The Cougars were three-hit by the South Bend White Sox.

On April 21, game three of the season, the Cougars would score their first home win. Against the Kenosha Twins, they won 6-3. Matt Anderson got the win, and Joe Borowski got the save in front of 2,177 fans.

Kane County played Kenosha at the Hubert H. Humphries Metrodome on May 16. They were shutout 5-0 in front of an estimated crowd of six hundred people. Jim Dedrick took the loss.

In a wild game on May 28, the Cougars played host to the Waterloo Diamonds, losing 17-9. Michael Hebb started, followed by Todd Unrien, Mike Paveloff, Todd Pennington, and infielder Jose Millares. In all, the Diamonds had 21 hits. Hebb and Unrien combined to give up 14 of the runs in just over five innings.

Matt Anderson pitched a complete game four-hitter on June 1, 1991, against Kenosha. He gave up three unearned runs in the third inning. A hit batter and an error led to the Twins scoring. Anderson didn't walk anyone and struck out eight. Greg Zaun hit a solo homer in the third inning for the Cougars.

Tom Martin got the win and Joe Borowski got the save for the Cougars over the Beloit Brewers on June 15. Rob Blumberg started the game and gave up three runs on four hits in just over two innings. Brad Miller hit a homer for the Cougars.

The Cougars pounded the Peoria Chiefs on June 18 in game two of a double header, 12-1. Bobby Chouinard pitched a complete game (seven innings for each game of a double header in

the minors). He gave up eight hits and one run to get his first Cougar win. Jim Roso, Manny Garcia, and Scott McClain had two hits apiece.

The second half of the season was a different story for the Cougars, as they went from worst to first and made the playoffs. In the second half they went 42-27 and were three games better than Rockford.

The Appleton Foxes lost to the Cougars, 8-7, on July 27. Vaughn Eshleman got the win. Tom Martin give up five hits without getting an out, posting five earned runs in the ninth inning. The score was 8-2 when he came on to pitch. The Foxes scored five runs in the bottom of the ninth, compared to the Cougars who scored two runs in the top of the inning.

Matt Anderson pitched another good game on August 9 in Rockford, versus the Expos. He pitched a complete game three-hitter but lost, 1-0. He gave up three hits, along with three walks, while also striking out three. The Expos' Ralph Diaz pitched a complete game three-hitter to get the win.

The Cougars lost in the first round of the playoffs to the Madison Muskies, 2-0.

The 1992 Cougars finished the year 15 games below .500 on the field, but in the stands they drew 323,000 fans. The Cougars did have some talent on the squad, even with the poor record. Curtis Goodwin, Scott McClain, Alex Ochoa, and B.J. Waszgis were in the field. Chouinard, Rick Forney, Jimmy Haynes, Scott Klingenbeck, Rick Krivda, Chris Lemp and Jose Mercedes were on the mound.

Alex Ochoa was named to the post season all-star team. He was also named the fifth best prospect in the league. Ochoa finished seventh in hitting. Bobby Chouinard ended up leading the league in pitching, with Forney and Haynes also in the top ten.

In a 13-2 game in Madison, Keith Schmidt hit his second and third homers of the year, and Rick Forney got his first Cougars win, going seven innings only giving up three hits. Schmidt had three hits, Goodwin and Don Gilbert had two hits apiece.

On May 3, the Cougars lost 20-2 in Appleton. Starter Rick Krivda got hammered in his two-plus innings of work. He gave up eight hits and eleven runs, walking six with just one strike out. Mark Johnson and Ed Gerald tagged Krivda with homers before he would leave. The Foxes only hammered out 15 hits.

Jimmy Haynes got his first Cougar win on May 3 in Appleton. He went into the eighth inning, giving up six hits and three runs, while walking one and striking out six. The Cougars got four doubles and two stolen bases in the game. Chris Lemp got his third save of the year, going an inning and two thirds.

Rick Forney threw a five-hit complete game shutout against the Clinton Giants on May 28 to extend his league-leading ERA to 1.53. He struck out six in the game.

Rick Krivda lost a 1-0 game against the Beloit Brewers on June 25. He pitched a complete game six-hitter, with 12 strikeouts. Future major leaguer Jeff Cirillo drove home Gordon Powell Jr. for the only run. The Cougars managed six hits.

Against Appleton, the Cougars would lose, 10-3, on August 15. Jose Mercedes got roughed up, giving up ten hits and eight runs in just over two innings. The next night the Cougars would beat the Foxes, 10-5. Scott Klingenbeck pitched seven innings, and Matt Jarvis picked up the win. The next night the Cougars lost 2-1. Chouinard pitched a complete game, giving up seven hits and one earned run. In the last game of the series Jose Mercedes pitched a complete game nine-hit shutout, striking out eleven.

The first two seasons were in the books, and it looked like the Cougars were here to stay.

Appleton at Cedar Rapids
Waterloo at Clinton
Kenosha at Burlington
Quad City at Peoria

4/12/91

COUGARS 8, WHITE SOX 0

Kane Co.	ab	r	h	S. Bend	ab	r	h
Hicks cf	4	1	1	Valrie rf	4	0	0
Ramierez ss	5	1	1	Walker 1b	4	0	1
Godin dh	4	1	0	Poe lf	2	0	0
Miller 1b	5	2	3	Robledo c	2	0	0
Schmidt lf	4	2	2	Nunez c	1	0	1
Peredes rf	3	0	0	Strange 3b	4	0	1
DiMarco 3b	4	0	2	Ramos ss	4	0	1
Garcia 2b	4	0	1	Hairston dh	3	0	0
Zaun c	3	1	0	Salomine ph	1	0	0
				Monzon 2b	3	0	0
				Gather ph	1	0	0
				Sheppard cf	2	0	1
				Coughlin cf	2	0	0
Totals	36	8	10	Totals	33	0	5

Kane County 100 102 400 —8 10 0
South Bend 000 000 000 —0 5 1

HR—Schmidt. 3B—None. 2B—Miller (2), Ramirez, Ramos.

Kane County	IP	R	ER	H	SO	BB
Blumberg	4	0	0	3	6	3
Borowski (W1-0)	4	0	0	2	4	1
Paveloff	1	0	0	0	1	0

South Bend	IP	R	ER	H	SO	BB
Bere (L0-1)	6	4	4	6	7	2
Young	1	4	3	4	1	1
Altffer	1	0	0	0	0	1
Shepherd	1	0	0	0	1	0

HPB—none. WP—none. PB—none.

High School A-3328

SOUTH BEND 13, KANE CO. 0 4/13/91

South Bend	ab	r	h	Kane Co.	ab	r	h
Valrie rf	5	1	1	Peredes cf	4	0	0
Galther rf	0	1	0	Ramirez ss	4	0	0
Walker 1b	5	2	3	Godin dh	3	0	1
Poe lf	5	2	1	Miller 1b	4	0	0
Strange 3b	2	2	0	Schmidt lf	4	0	0
Ramos ss	4	1	1	DiMarco 3b	3	0	0
Hairston dh	4	1	1	Davis rf	3	0	0
Monzon 2b	3	1	1	Millares 2b	2	0	0
Sheppard cf	3	0	0	Roso c	3	0	1
Coughlin cf	2	1	1				
Nunez c	5	1	3				
Totals	38	13	12	Totals	30	0	3

South Bend White Sox 010 000 507 —13 12 1
Kane Co. Cougars 000 000 000 —0 3 2

LOB—South Bend 12, Kane County 5. HR—None. 3B—None. 2B—Munzon.

South Bend	IP	R	ER	H	SO	BB
Jenkins (W)	8	0	0	3	3	0
Caridad	1	0	0	0	0	1

Kane County	IP	R	ER	H	SO	BB
Martin (L)	4	3	0	3	4	3
Hebb	2⅓	5	5	4	1	5
Wiley	1½	0	0	2	2	2
Pennington	0	6	5	2	0	3
M. Garcia	1	1	1	1	0	1

HPB—None. WP—Martin (1), M. Garcia (1).
PB—None. E—D.Marco

These are the box scores from the first two games in Cougars history, taken from the *Daily Herald Newspaper*. The one on the left is the first game, which was played in South Bend. The Cougars won that game. The one on the right is the second game, which the Cougars lost, the first ever home game for the Cougars.

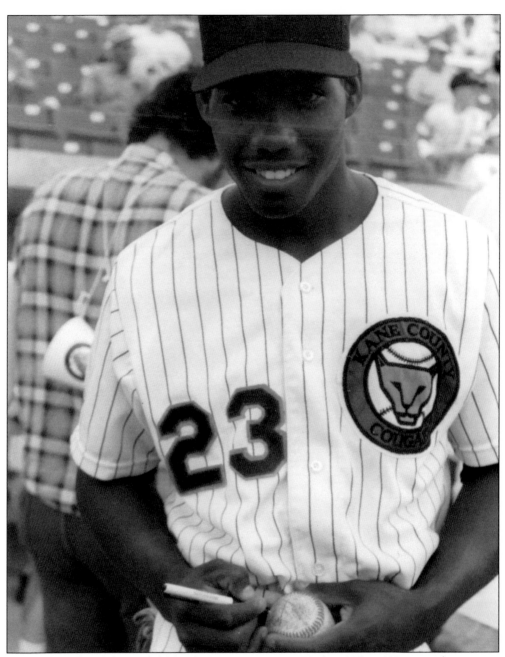

Alex Ochoa played the outfield for the Cougars in 1992. He hit .295 in 133 games, hitting one homer, 22 doubles, and seven triples. He drove in 59 runs that year. Since then he broke into the majors with the New York Mets in 1995, after being in the trade that brought Bobby Bonilla to Baltimore. He hit .297 with the Mets in 11 games. Ochoa would spend parts of the next two seasons in New York. In 1997, the Mets traded Alex to Minnesota for Rich Becker. In his one season in the Twin Cities he hit .257 in 94 games. After that he spent time in Milwaukee, Cincinnati, and Colorado before being traded to Anaheim in the middle of the 2002 season. He was an all-star in the Midwest League (1992), Carolina League (1993), and International League (1995). (Photo by Pam Rasmussen.)

Bobby Chouinard pitched for the Cougars in the 1991 and the 1992 seasons. In 1991, he pitched in six games and went 2-4 with a 4.64 ERA. Opponents hit .328 against him. In 1992, he went 10-14 with a 2.08 ERA in 26 games. He had nine complete games. Since then he has moved around a bit. He made his major league debut in 1996 with Oakland after spending the previous four years in their farm system. He went 4-2 with a 6.10 ERA in Oakland in 13 games. The next time he saw the majors would be in 1998, when he pitched in one game for Milwaukee and gave up a run in three innings of work. He was then put on waivers and claimed by Arizona. He pitched in 26 games for the Diamondbacks that year, coming away with a 0-2 record and 4.23 ERA. Chouinard spent one more year in Arizona before being released and signing with Colorado. He would split the next two seasons between the Rockies and Triple A. (Photo by Pam Rasmussen.)

B.J. Waszgis caught for the Cougars in 1992. He hit .215 in 111 games with 11 homers and 18 doubles. After that he took a winding road that eventually led to 24 games in the majors in 2000. In 1994 he was a Carolina League all star at Frederick, hitting .282 with 21 homers in 122 games. From 96-00 he would play in AAA with Rochester, Pawtucket, Columbus and finally Oklahoma before coming up and playing with the Texas Rangers. In the majors he hit .222. The next year he was in AAA again, this time in Calgary.—Photo by Pam Rasmussen

Curtis Goodwin played in the outfield for the Cougars in 1992. He hit .282 in 134 games with one homer, seven doubles and five triples. He stole 26 bases. After that he would rise to the majors in 1995 with Baltimore, where he hit .263 in 87 games with the Orioles. He was then traded to the Reds for David Wells. In 1996, with Cincinnati, he hit .228 in 49 games. He spent one more season in Cincinnati, before being traded to Colorado in 1998. There he hit .245 in 119 games. The Chicago Cubs then picked him up off waivers just before the 1999 season. He hit .242 in 89 games for the Cubs. In August of 1999 he was released and picked up by Toronto, were he didn't get a hit in eight at bats. He spent the 2000 season in the independent leagues with Atlantic City, Sonoma County, and Solano before getting to play 11 games towards the end of the season in Wichita for the Royals. The 2001 season saw Curtis struggle in Oklahoma, eventually getting his release and going back to play for Solano. Goodwin was the Howe Sportsdata Star of Stars for the 1993 Carolina League All-Star Games. He was also an all-star in the Eastern League in 1994. (Photo by Pam Rasmussen.)

Chris Lemp was the Cougars closer in 1992. He went 2-3 with a 3.46 ERA. Chris had 26 saves in 58 games. One of those 58 games was as a starting pitcher. For 1993, he moved up to Frederick and went 4-1 with a 3.56 ERA in 52 games. He also earned eight saves. He appeared at Frederick again for the 1994 season. Chris went 5-5 with a 2.71 ERA in 52 games. With 21 saves, he led the Orioles in saves in their minor leagues. In 1995, Chris moved up to Bowie and went 2-4 with a 5.40 ERA in 18 games, earning four saves. He also pitched in Rochester, going 0-1 with an 11.25 ERA in 3 games. Again in 1996, Lemp went to Bowie, this time he pitched in 27 games. He went 1-3 with a 4.72 ERA and one save. (Photo by Pam Rasmussen.)

Jimmy Haynes was a starting pitcher for the Cougars in 1992. In that year he went 7-11 with a 2.56 ERA in 24 games, he had four complete games. Over the next few years he would spend a lot of time in Rochester, from 1994 to 1997 he spent parts of each of those season there, going 19-13. He made his major league debut in 1995 with the Orioles. In that year he went 2-1 with a 2.25 ERA in four games. He was traded to Oakland for Geronimo Berroa in 1997 In Oakland he spent three seasons in the majors going a combined 21-27. The A's traded him to Milwaukee in 2000, in two years he went 20-30 in a Brewers uniform. In January of 2002 he signed with Cincinnati as a free agent and spent two seasons there. He went a combined 17-22. Jimmy was a Double-A all-star pitcher for the Eastern League in 1994. (Photo by Pam Rasmussen.)

Rick Krivda was a starting pitcher for the Cougars in 1992. He went 12-5 with a 3.30 ERA in 18 games, and he had two complete games. After pitching 31 games between Frederick and Bowie the net two years he went to Rochester, where he spent the majority of the next five seasons. In those years he went 35-18 for Rochester. He also pitched 45 games for the Baltimore Orioles. In 1998, he was waived by the Orioles and claimed by Cleveland where he went 2-0 with a 3.24 ERA in eleven games before being traded to Cincinnati in June. He went 0-2 with an 11.28 ERA in Cincinnati and was released in August. He spent the 2000 season back in Rochester for the Orioles, were he went 11-9 with a 3.12 ERA in 26 starts. He spent the 2001 season in Memphis but was released by the Cardinals in July. Rick was a 1997 Triple-A all-star. (Photo by Pam Rasmussen.)

Scott McClain was the third baseman for the Cougars in 1991 and 1992. In 1991, he hit .222 in 25 games. The next year he hit .266 in 96 games. In 1996, for Rochester, he hit .281 with 17 homers and 69 runs batted in. The next spring training he and Manny Alexander were sent to the New York Mets. Scott would make his debut in the majors with Tampa Bay in 1998. He hit .100 in 20 at bats. After the 2000 season, in which he hit .276 for Colorado Springs with 25 homers, he went and played ball in Japan. In his first season over there he hit .247 with 39 homers. The next two seasons he also spent in Japan playing for Seibu, where he hit a combined 28 homers. (Photo by Pam Rasmussen.)

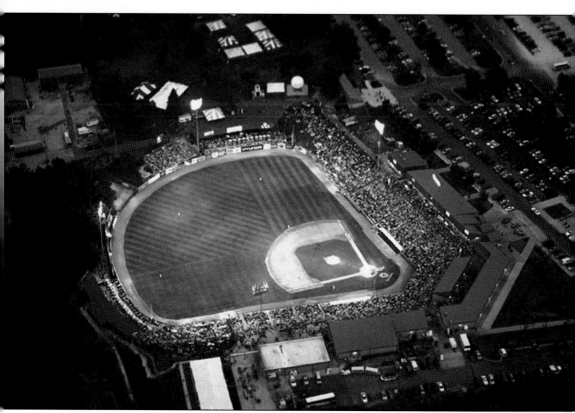

From humble beginnings playing Single-A ball at Elstrom Stadium, several former Cougars have gone on to make an impact in the big leagues. Joe Borowski was a reliever for the Cougars in their first year. He went 7-2 with a 2.56 ERA in 49 games. Joe had 13 saves and opponents hit .207 against him. Over the next three seasons he would play for Frederick, Bowie, and Rochester, and go a combined to go 10-9 with 27 saves. In 1995, he made his major league debut with Baltimore, appearing in six games and posting an ERA of 1.23. That winter he was traded to Atlanta for Kent Mercker. The next few years he pitched for Atlanta and the New York Yankees. He spent the 1999 season in Louisville were he went 6-2 with a 5.50 ERA. Going 6-2 with a 5.50 ERA for Newark of the Atlantic league in 2000, before being signed by Monterrey of the Mexican League in July were he went 4-2 with a 3.19 ERA. The Chicago Cubs signed him in December of 2000. In AAA Iowa he went 8-7 with a 2.62 ERA, and was then called up to Wrigley for a start. He gave up six runs in two innings in his comeback to the majors. The next two years he pitched very well in the Cubs bullpen, and in 2003 had 33 saves. Tom Martin went 4-10 in 1991 for the Cougars as both a starter and out of the pen. He started ten games and he also saved six. In February of 1992, he was traded to San Diego by Baltimore. He spent some of the 1992 season in Waterloo, Iowa, were he went 2-6 with a 4.25 ERA. Tom has been a left-handed specialist for Houston, Cleveland, New York Mets, Tampa Bay, Los Angles and Atlanta over the years.

Greg Zaun caught for the Cougars in 1991after spending the previous year in Wausau. In 1991 he hit .274 in 113 games. In 1993, playing for Bowie, he hit .306 in 79 games and was named to the all-star team. Zaun made his major league debut in 1995 for Baltimore, that year he hit .260 in 40 games. Over the next few years he would be in the majors with Florida, Texas, Kansas City, Houston, and Colorado. He was on the Marlins in 1997, the year they won the World Series. (Photo courtesy Kane County Cougars.)

THREE

1993–1995

The Cougars switched affiliations for the first time after the 1992 season. They went with the expansion Florida Marlins. In 1993, Charles Johnson made his pro debut for Kane County, fresh off spending the summer playing for Team USA in the Olympics and starring for the University of Miami. He was the Marlins first round pick in the 1992 draft.

The Cougars wouldn't make the playoffs, as they were in the middle of their division most of the year, but they had a big time, prospect-laden team. Charles Johnson hit 19 homers to set a new high for the Cougars. Reynol Mendoza was eighth in the league in pitching. Todd Pridy led the league in doubles. Hector Carrasco led the league in games started. Pat Leahy led in hit batsmen. Johnson, who led the league in total bases and runs batted in, was named to the post season all-star team and was also voted the top prospect of the Midwest League. Vic Darensbourg was also named to the all-star team. And that's not even to mention shortstop Edgar Renteria.

On April 10, Charles Johnson hit his first professional homer. It came in Beloit during a 17-3 Cougar romp of the Brewers. Darensbourg got the win. Pookie Wilson got four hits in six at bats. Dan Robinson and Todd Pridy both had two hits.

Pat Leahy pitched a complete game four-hitter on April 28 against Waterloo. In the game he gave up two earned runs, while striking out six Diamonds. The Cougars would win the game, 10-3. Wilson had three hits, while Johnson, Pridy, and Chris Sheff each had two hits.

The 1993 Midwest League All-Star Game star was played in Kane County. Charles Johnson and Chris Sheff each got hits in the game. The Northern squad beat the Southern squad, 3-2

Edgar Renteria hit his first and only home run as a Cougar on June 28, against the Burlington Bees. He hit a three-run homer off of Ivan Artega in the second inning to help the Cougars cruise to an 11-3 win.

Tony Saunders pitched a complete game eight-hitter on August 14. He gave up one run, a second inning shot by Mike Gulan of the Springfield Cardinals. Saunders struck out eight in the game. Eddie Christain and Johnson both had three hits.

The 1994 Cougars also had some stars on the roster. Dave Berg, Todd Dunwoody, Billy McMillon, Kevin Millar, Ralph Milliard, Mike Redmond, Antonio Alfonseca, Will Cunnane, Felix Heredia, Marc Valdes, and Bryan Ward all played on the team in that season.

The team was again in the middle of the division standings all year and would not make the playoffs for the third straight season. Millar was eighth in the league in hitting. Will Cunnane led the league with a 1.43 ERA. Andy Larkin was sixth. Milliard led the league in runs. Millar led in total bases. McMillon led in runs batted in and walks. Cunnane also led in shutouts. Larkin led in hit batsmen. Millar and McMillon would be named to the post season all-star team, and Cunnane ranked the eighth best prospect in the league.

Kevin Millar hit a three-run homer in the first inning on April 17 off of the Clinton Giants' Brock Smith to help the Cougars to a 6-1 win. Dan Ehler pitched six innings, giving up eight hits and one run. Ward would get his first save. Two days later against the Peoria Chiefs, Millar would hit two homers to help the Cougars to a 10-2 win. Both homers were off of Brent Woodall, a two-run homer in the fourth inning and a solo shot in the sixth.

The Cougars won, 18-6, over the Appleton Foxes on May 8 in Appleton. They scored 10 runs in the top of the ninth off of two relievers. The Foxes first run was driving home by Alex Rodriguez, who tripled off Cougar starter and winner Marc Valdes. Billy McMillon had two homers

The Fort Wayne Wizards scored seven runs in the top of the ninth, after the Cougars had scored five of their own in the bottom of the eighth inning to untie the game at three on July 10. Billy McMillon and Kevin Millar both hit homers.

Glendon Rusch of the Rockford Royals no-hit the Cougars on August 7, 1994, in Kane County as the Royals won, 9-0. Rusch walked one and strike out eleven Cougars.

The 1995 Cougars did something that the previous three teams couldn't do—they made the playoffs, even though they were beaten by the West Michigan Whitecaps two games to one. The Cougars had a lot of talent on the squad. Luis Castillo, Todd Dunwoody, Amaury Garcia, Ryan Jackson, Hector Kulian, Victor Rodriguez, and Brian Meadows all played for Kane County that season.

The team was second in the league in hitting with a .264 average. Castillo was fourth in the league in hitting. Jackson led the league in doubles. Walter Miranda led the league in walks. Castillo, Dunwoody, and Jackson all made the post season all-star team. Dunwoody was named the fourth best prospect in the league, while Castillo was fifth.

The Cougars won a 19-15 game against the Clinton Lumberkings on April 18, with 35 hits between the teams. The Cougars scored 14 runs in the third inning, while the Kings scored eight in the sixth. Aaron Harvey, Victor Rodriguez, Todd Dunwoody, and Ryan Jackson each had three hits, while John Roskos went five for six at the plate.

Brain Meadows pitched a complete game four-hitter against the Beloit Brewers on May 2. He struck out six. Kelley Wunsch pitched a complete game four-hitter for Beloit. He gave up the run in the second inning, which would give the Cougars the 1–0 win.

The Springfield Cardinals split a double header against the Cougars on June 3. In the first game, Gregg Press pitched a complete game three-hitter; he gave up the only run of the game in the fourth inning. In game two, the Cougars won 4-0. Dan Zanolla and Jamie Ybarra pitched well. Matt Treanor, a future Cougar, played for Springfield and went hitless in four at-bats.

The Cougars would win in the bottom of the ninth on June 7 against the Wisconsin Timber Rattlers. With Amaury Garcia on third and two outs, Luis Castillo bunted and beat out the throw to score Garcia, the winning run. The Cougars had to score twice in the ninth.

Mike Parisi pitched a complete game five hitter, giving up one run and one walk, while striking out six in a 15-1 win over Beloit on June 28. John Cady hit two homers. John Roskos went four for five. Ryan Jackson also had three hits.

The Cougars would get their first playoff game victory on September 4, 1995, in game two of the series against West Michigan. Gabe Gonzalez got credit for the win. Todd Dunwoody hit a homer.

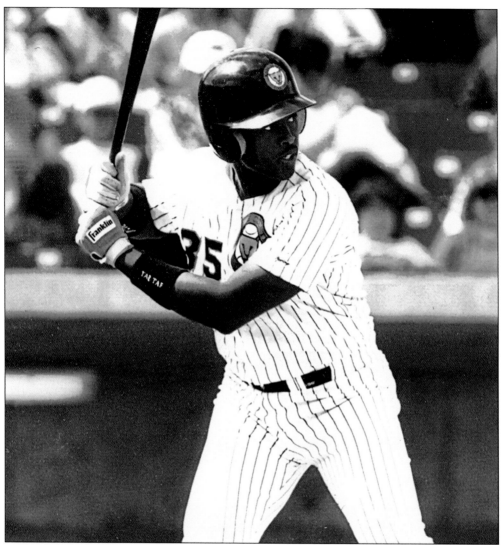

Charles Johnson made his professional debut with the Cougars in 1993, hitting .275 with 19 homers in 135 games. The next year he went to Portland and hit .264 in 132 games with 28 homers. He spent the next four years in Miami as their backstop, and the Marlins traded Johnson to the Dodgers in May of '98 for Mike Piazza. In L.A. he hit .217 in 102 games. In December of that year he was shipped off to Baltimore for Todd Hundley. Charles spent most of the next two seasons in Camden Yards. He hit .294 in 2000 with the Orioles. In 2000, the Orioles traded him along with Harlod Baines to the Chicago White Sox. On the South Side he hit .326 in 44 games. As a free agent in 2000, Charles resigned with the Marlins and hit .259 in 128 games with 18 homers. In November of 2002, he was traded to Colorado by the Marlins along with Darensbourg for Mike Hampton and Juan Pierra. Johnson was a 1993 Midwest League All-Star, and '94 Eastern League All-Star. He won the Gold Glove award in the National League in 1995, '96, '97 and '98. He was selected to the Major League All-Star Games in 1997 and 2001. (Photo courtesy Kane County Cougars.)

Alex Gonzalez played shortstop for the Cougars in 1996, for just four games. He had two hits in 10 at-bats. After he played for the Cougars, he went to Portland for the rest of 1996 and all of 1997. In 1998, he was a call up to the Marlins and hit .151 in 25 games. Gonzalez has been with the Marlins ever since. In 1995, he was a Gulf Coast League All-Star. In 1997, Alex was named Howe Sportsdata Comeback Player of the Year and an Eastern League All-Star. In 1999, he was selected to the Major League All Star Game. (Photo by Pam Rasmussen.)

Andy Larkin pitched for the Cougars in 1994 and went 9-7 with a 2.83 ERA in 21 starts. He had three complete games. He played part of the next season in Portland. Andy made his major league debut in 1996 with Florida, pitching five innings, giving up three hits and one run. The next two seasons were spent in Triple-A Charlotte. In 1998, he made 14 starts for the Marlins and went 3-8 with a 9.64 ERA. In 2000, Larkin signed with the Reds and pitched three games with Cincinnati, then was waived and claimed by Kansas City. He pitched 18 games, going 0-3 with an 8.84 ERA with the Royals. He spent the 2001 season in Colorado Springs going 4-8 with a 5.40 ERA. (Photo by Pam Rasmussen.)

Antonio Alfonseca pitched for the Cougars in 1994 going 6-5 with a 4.07 ERA in 32 games, with nine starts. The previous year he was picked up by the Marlins from the Expos in the rule five draft. After Kane County, he went directly to Portland in 1995. Two seasons were spent mainly in Charlotte, were he went 11-6 in 60 games. Antonio made his major league debut in 1997 with the Marlins, going 1-3 with a 4.91 ERA. He spent 1998 through 2001 with the Marlins racking up 102 saves. In 2002, he and Julian Tavarez were traded during spring training to the Cubs for an unknown pitcher named Dontrelle Willis, along with Matt Clement. He had 19 saves for the Cubs in 2002 over 66 games. (Photo by Pam Rasmussen.)

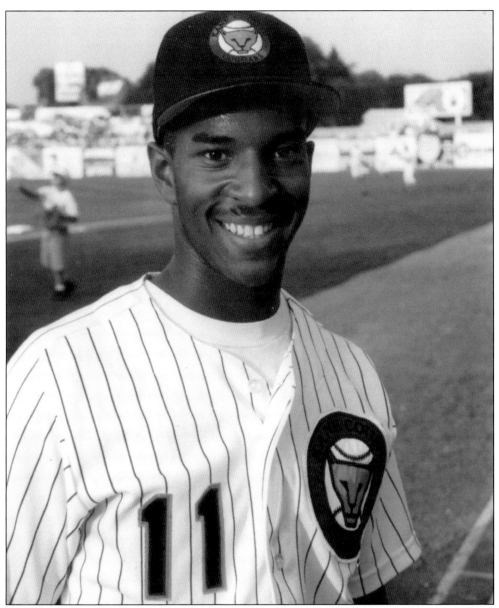

Billy McMillon played the outfield for the Cougars in 1994. He hit .250 in 137 games with 17 homers. After that he went straight to Portland were he hit .313 and hit 14 homers. After going to Charlotte and hitting .352 with 17 homers in 1996, Billy made his major league debut with the Marlins later that year. He played for the Marlins in 1996 and '97. In 1997, he was traded to Philadelphia for Darren Daulton and spent the next three seasons in Scranton/Wilkes-Barre. In 2000, he signed with Detriot and would play 46 games for them, hitting .301; he hit .345 for their Triple-A club in Toledo that year. The following season saw him hit .088 for Detroit, and then get waived and sign with Oakland where he would hit .293. He hit .333 for Sacramento in 2003, and then hit .268 for Oakland later in the year. Billy was a Midwest League All-Star in 1994. In 1995 he was a Double-A All-Star, and in '96 a Triple-A All-Star and International League Rookie of the Year. (Photo by Pam Rasmussen.)

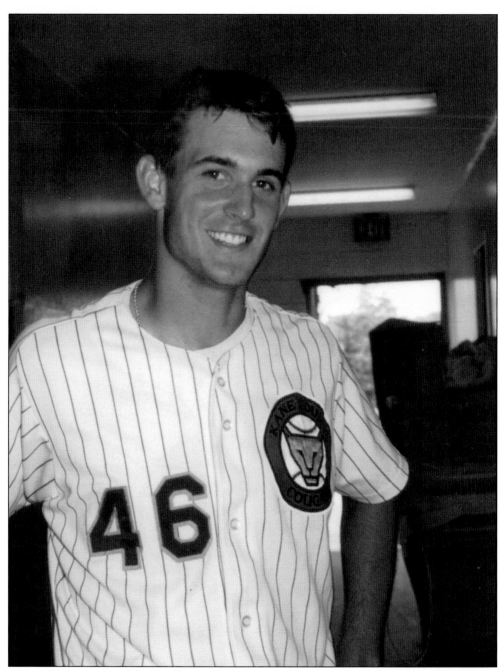

Brian Meadows pitched for the Cougars in 1995 and went 9-9 with a 4.22 ERA in 26 starts, he had one complete game. Brian made his major league debut in 1998 with the Florida Marlins, he spent the 98 and 99 seasons in Miami. He went a combined 22-28 in 62 games. He was traded to San Diego in 2000 for Dan Miceli. In San Diego he went 7-8, 5.34. Brian was traded at the deadline to the Royals for Lay Witasick. Over the next two years he spent in Kansas City he went 7-8 in 22 games. In 2002 he signed with the Pirates and went 1-6, 3.88 in 11 games. Then in 2003 he went 7-0, 1.41 in Nashville which earned him another chance in Pittsburgh. He went 2-1, 4.72 in 34 games. (Photo by Pam Rasmussen.)

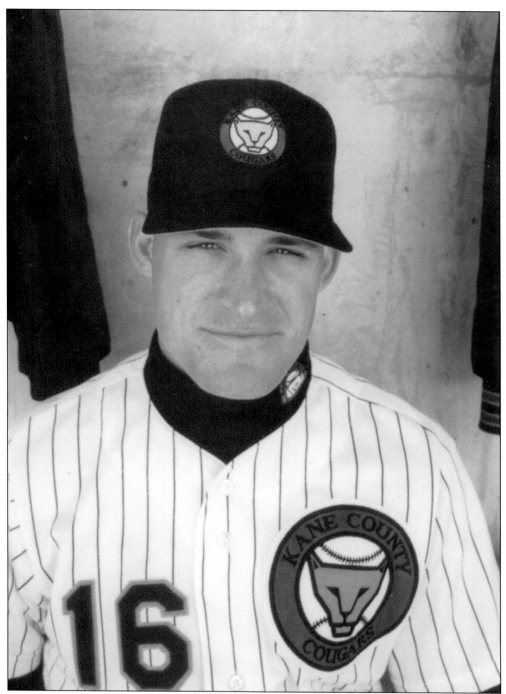

Dave Berg played for the Cougars in 1994. He hit .268 in 121 games with nine homers. He would hit .298 the next season in Brevard County, then .302 in Portland in '96, and .295 in Charlotte in '97 before making the Marlins in 1998. That season, his first in the majors, he hit .313 in 81 games. Berg played for the Marlins for the next two seasons. In 2002, he signed with Toronto where he hit .270 in 109 games, and .255 in 61 games in 2003. Berg is a career major league .270 hitter. (Photo by Pam Rasmussen.)

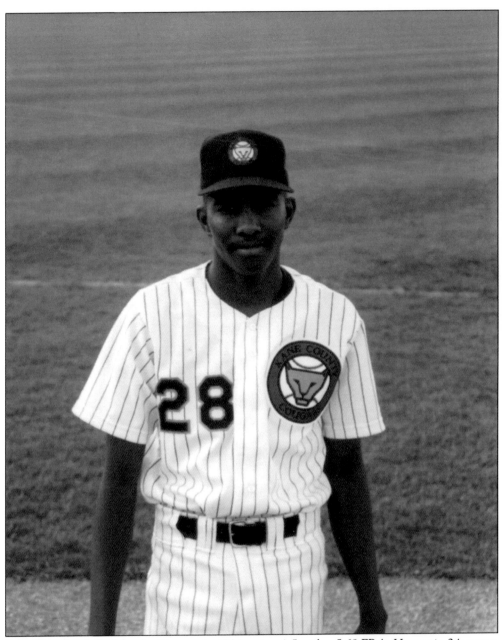

Felix Heredia pitched for the Cougars in 1994, going 4-5 with a 5.69 ERA. He was in 24 games, starting eight. He pitched one complete game and also had three saves. In 1996, Heredia made his major league debut with the Marlins. He spent the next three seasons in Florida going a combined 6-7. He was traded to the Cubs in 1998 for Kevin Orie and Todd Noel. In Chicago he went 3-0, with a 4.08 ERA in 30 games. He spent the next three seasons on the north side going a combined 15-6 in Chicago. He was traded to Toronto in 2002 for Alex Gonzalez (not the one with the Marlins). In 53 games in Toronto he went 1-2 with a 3.61ERA. He signed with the Reds in 2003, and went 5-2, with a 3.00 ERA before being waived and claimed by the New York Yankees. In the Bronx he went 0-1, with a 1.20 ERA in 12 games. Felix was 1996 Howe Sportsdata All-Teen Team. (Photo by Pam Rasmussen.)

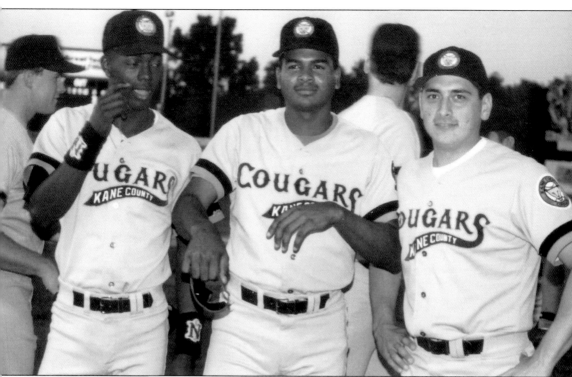

Edgar Renteria (left) is pictured with Hector Carrasco and Reynol Mendoza. Renteria was a 17-year-old shortstop when he played for the Cougars in 1993. He hit .203 in 116 games with one homer. In 1996, he made his major league debut with the Marlins and hit .309 in 106 games. He spent the next two seasons in Florida. In 1997, he drove home Craig Counsel to win the World Series for the Marlins. In 1999, he was traded to St. Louis for Pablo Ozuna, Braden Looper, and Armando Almanza. As a Cardinal he has been spectacular, routinely hitting well and fielding even better. He hit .305 in 2002 and .330 in 2003. He won the Gold Glove Award in 2002, and was selected to the all-star games in 1998 and 2003. Reynol Mendoz pitched for the Cougars in 1993, and later became the Cougars pitching coach in 2001. (Photo by Pam Rasmussen.)

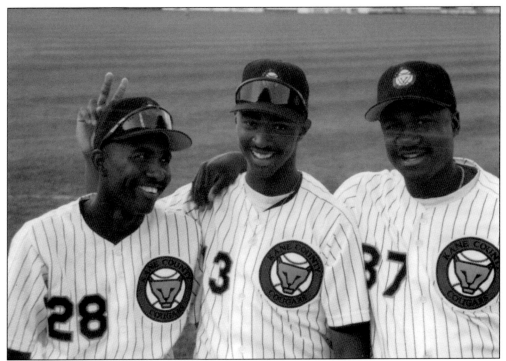

Pictured, from left to right, are Felix Heredia, Marcus Mays, and Antonio Alfonseca with the 1994 Cougars. Two out of three of them would make it to the Marlins bullpen and major league careers. (Photo by Pam Rasmussen.)

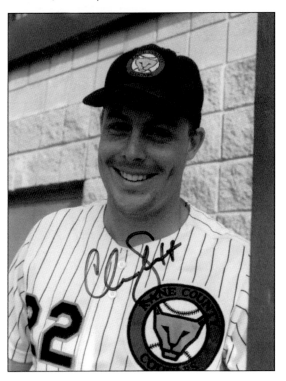

Chris Sheff played for the Cougars in 1993. He hit .272 in 129 games with 33 stolen bases. In 1994, he hit .373 in Brevard County in 32 games. Sheff then hit .256 in Portland after a call up in 106 games, hitting five homers. In 1996, he hit .276 for Portland in 131 games with 12 homers and 23 stolen bases. The Marlins sent him back to Portland in 1996 and he hit .295 in 27 games, then went to Charlotte and hit .264 in 92 games with 12 homers. He hit .255 in 1997 for Charlotte with 11 homers in 120 games. (Photo by Pam Rasmussen.)

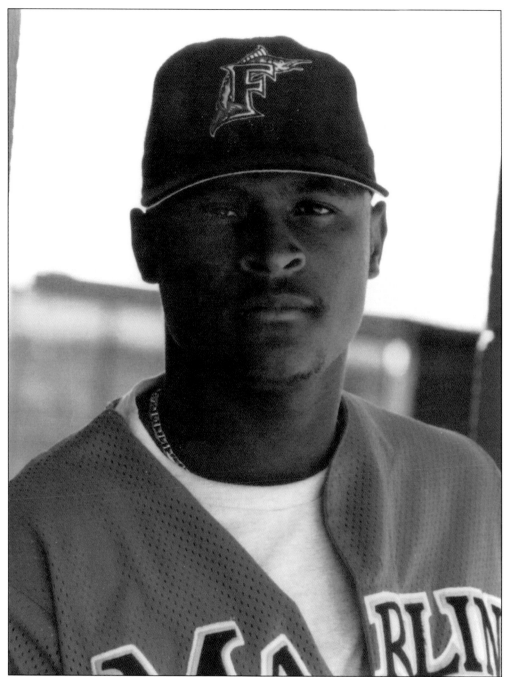

Luis Castillo played for the Cougars in 1995. He hit .326 in 89 games, scoring 111 runs. After that he hit .317 for Double-A Portland. He entered the majors in late 1996 with the Marlins, where he hit .262 in 41 games. In the next two years he would go between Charlotte and Florida every year. In 1997, he hit .354 in Charlotte in 37 games. Since 1999, he has been the Marlins regular second baseman, hitting over .300 all but one season. In '95 he was a Midwest League All-Star. Luis was selected to the National League All-Star team in both 2002 and 2003. (Photo by Pam Rasmussen.)

Kevin Millar played for the Cougars in 1994 and hit .302 in 135 games, belting 19 homers. The year before, he was playing for St. Paul in the independent Northern League. After his trip to Kane County, he hit .288 in Brevard County in 1995, .318 and .342 in Portland in '96 and '97. He made the Marlins for two games in the 1998 season, but also hit .326 for Charlotte. In 1999, he hit .301 in Calgary, and then hit .285 for the Marlins. For the next three seasons he would be with the Marlins on a regular basis. He hit .276 for the Boston Red Sox in 2003 after signing there in the off season. Millar was a Midwest League All Star in 1994, and Eastern League Most Valuable Player in 1997. (Photo by Pam Rasmussen.)

Kevin Millar (left) poses with Lynn Jones. Jones managed the Cougars for five years. He was the Cougars manager from 1994 to 1997, compiling a record of 350-335 and a playoff record of 8-4. In 2004, Jones was the third base coach for the Boston Red Sox. Millar was an outfielder/first baseman for the Red Sox in their championship run. (Photo by Pam Rasmussen.)

Ryan Jackson played for the Cougars in 1995 as a outfielder. In that year he hit .293 in 132 games with 10 homers. After leaving the Cougars he hit .308 in Brevard County in 96 and .312 in Portland in 97. After hitting .380 for Charlotte in 98, he would get called up to the majors for a part of that season with the Marlins. In the majors he hit .250 in 111 games. Ryan was then brought in to Seattle for part of the 99 season. He also played in Tacoma were he hit .308 in 105 games. 2000 saw him back in the International League, this time with Durham where he hit .311 in 139 games with 18 homers. That got him signed by Detroit where he bounced between Detroit and Toledo for the next two years. He was brought back to Durham for the 2003 season where he hit .303 in 131 games. (Photo by Pam Rasmussen.)

Todd Dunwoody was an outfielder for the Cougars in 1995. He hit .283 in 132 games with 14 homers and eight triples. The next year he got sent to Portland (AA Eastern League) where he hit .277. In 1997, he spent time in both Triple-A Charlotte and in the majors with Florida. That is how it went for him for the next two years. After the 1999 season he was traded to Kansas City, and again spent time between Triple-A and the majors, this time with Omaha and the Royals. January of 2001, he signed with the Cubs and split time between Triple-A Iowa (Des Moines) and Chicago. The next two years were nothing different, only with a different organization, the Cleveland Indians. Todd was an all-star in 1995 with the Cougars. In 1996, he was an Eastern League All-Star. In 1997, he was an International League All-Star. (Photo by Pam Rasmussen.)

Victor Darensbourg was in the bullpen for the Cougars in 1993. He went 9-1 with a 2.14 ERA in 46 games, with 16 saves. In 1994, he went 10-7 with a 3.81 ERA in Portland, pitching both in the rotation and out of the bullpen. He would make it to the Marlins in 1998 and go 0-7 with a 3.68 ERA in 59 games. After four more seasons in Florida, in which he went a combined 7-15, he was traded to Colorado. In the trade the Marlins got Mike Hampton and Juan Pierre in 2002. Darensbourg spent the last half a season in Colorado before drawing his release. He was signed by Montreal and worked out of the Expos bullpen. (Photo by Pam Rasmussen.)

Victor Rodriguez played shortstop for the Cougars in 1995. He hit .235 in 127 games. The next year he got to Brevard County and hit .274. The next three years he spent in Portland. In 2000, he was traded to Cleveland, and played for Kinston and Akron. In 2001, he was signed by the Yankees, and played for Tampa and Norwich, hitting .272 and .294. Victor spent another year in the Eastern League in Altoona, hitting .293. The 2003 season started with him signing with Campeche of the Mexican league, and by May he was signed by the Royals and went to Wichita where he hit .326 before being traded to the Dodgers. The 2004 season saw Victor named by *Baseball America* as the Independent League Most Valuable Player, playing in the Atlantic League. (Photo by Pam Rasmussen.)

Mike Redmond played for the Cougars in 1993 and 1994. In 1993, he hit .200 in 43 games as the backup to Charles Johnson. In '94 he hit .271 in 92 games. After that he spent the next two seasons in Portland where in 1996 he hit .287 in 120 games. In 1998, he made his major league debut with the Marlins and hit .331 in 37 games. Mike was with the Marlins as their backup catcher for the next five years. He is a career .290 hitter in the majors. (Photo by Pam Rasmussen.)

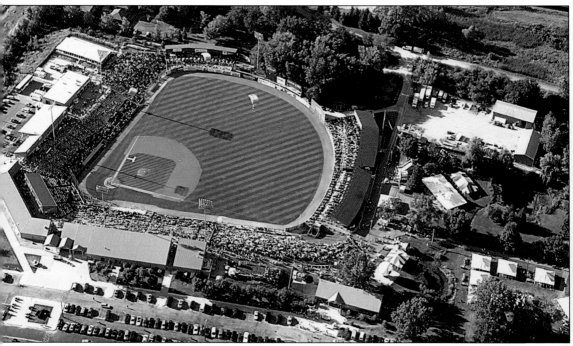

Fans at Elfstrom Stadium watched the '93 Cougars team produce some talented major leaguers. Hector Carrasco pitched for the Cougars in 1993, going 6-12 with a 4.11 ERA in 28 starts. Before he came to the Cougars he went through the Mets and the Astros system. In 1994, he was traded to Cincinnati and spent four years in the Reds bullpen going a combined 12-18. In 1997, he was traded to the Royals, and would go 1-6 with a 5.45 ERA in 28 games there. Hector was selected in the expansion draft by Arizona in 1997, was waived in spring training, and then picked up by the Twins. In Minnesota, Carrasco spent the next four years in their bullpen, going a combined 14-11. He pitched the 2003 season in Ottawa and Baltimore appearing in a combined 73 games and having a record of 6-8.

Chris Clapinski played for the Cougars in 1993, hitting .210 in 82 games. He spent the next four years in the minors with the Marlins before being called up to Miami in 1999. That season he hit .322 in Calgary. In 2002, he signed with the Dodgers as a free agent and went to Las Vegas, where he hit .295 and .317 in two years there. He's gone on to Louisville, Cleveland, and Buffalo.

Lou Lucca played third base for the Cougars in 1993, where he hit .277 in 127 games. He worked his way up to Charlotte by 1996, then would spend the next three years there. In '99 he was signed by Philadelphia and sent to Scranton/Wilkes-Barre were he hit .268 in 136 games. In 1999, he was signed by the Cardinals and spent the next two season in Memphis. After 2001, he signed to play in the Mexican league with Campeche. He hit .326 in 13 games there, and then played with Cordoba and Vaqueros of the Mexican League in 2003. He hit .285 and .370, before being signed by the Indians and assigned to Buffalo. (Photo Courtesy Kane County Cougars.)

Ozzie the Cougar, seen here as a bobblehead in his road jersey, was there as mascot for the 1994 and 1995 squads that sent several players up to the big leagues. Josh Booty played for the Cougars in 1995 and 1996. He owns the single season strike out record for the Cougars. After four years as the Marlins first round pick, he went back to Louisiana State University where he played quarterback. Booty now plays in the national Football League.

Amaury Garcia played for the Cougars in 1995 and 1996. He hit .241 in 26 games in '95, and .263 in 106 games in '96. Three years after playing in Kane County he made his major league debut with the Marlins, playing ten games in 1999. In 2000, he played for Calgary and hit .292 in 120 games, belting 13 homers. The Marlins traded him to the White Sox in 2000.

Gabe Gonzalez pitched for the Cougars in 1995, making his pro debut with them, he went 4-4 with a 2.28 ERA in 32 games out of the bullpen. In 1998, he would make his major league debut with the Marlins. He got into three games and left with a 9.00 ERA. After the 1999 season he was selected by the Expos in the rule five draft. He has since moved around a bit in the minors. John Roskos played for the Cougars in 1995 and hit .297 in 114 games with 12 homers. He then went straight to Portland and spent two years there hitting .275 and .308. In 1998, he played in both Charlotte and made his major league debut with the Marlins. In 1999, he hit .320 in Calgary in 134 games with 24 homers. That year he got into 13 games with the Marlins. He then became a free agent and signed with San Diego and spent most of the season in Las Vegas, hitting .318 in 99 games with 18 homers. He did play in 14 games with the Padres. After being released in spring training by the Padres he signed with the Cubs and played Triple-A ball in Iowa, hitting .256 in 34 games. Bryan Ward played for the Cougars in 1994, he went 3-4 with a 3.40 ERA in 47 games and had 11 saves. Over the next few years he played with Brevard County, Portland and Charlotte, before being released on waivers. The White Sox called on him and sent him to Birmingham. He made his major league debut with the White Sox and spent all of 68 games there over the next two years. In 1999, he signed with Philadelphia and was sent to Scranton/ Wilkes-Barre, then went to play for the Phillies. He was released by Philly in August and signed by Anaheim four days later. Ward spent seven games in Anaheim. After that year he went to Boston, and played mainly in Triple-A Pawtucket. (Photo by Alan Malamut.)

Four

1996–1998

The 1996 Cougars were in the middle of the pack in the standings throughout the season. They would finish three games below five hundred, 12 and a half games behind Peoria. The Cougars were third in the league in pitching, but near the bottom in hitting. Victor Hurtado finished ninth in the league in pitching. Josh Booty led the league in strikeouts with 195. Rod Getz led the league in losses with 14. Scott DeWitt and Hurtado led in hit batsmen. Josh Booty was named the eighth best prospect in the league.

The Cougars wouldn't have a bad team. They had talent like Roosevelt Brown, Amaury Garcia, Alex Gonzalez, Jaime Jones, Mark Kotsay, Nate Rolison, Randy Winn, Ryan Dempster, and Hurtado.

The Cougars won against Peoria, 14-13, on April 20. Amaury Garcia, Nate Rolsion, and Jaime Jones each hit homers. They scored 11 of those runs in the first three innings. That made it a seven-game winning streak for the Cougars.

The Cougars lost a 1-0 game to the Clinton Lumberkings on May 11 in Clinton. It was the first game of a double header, and they would win the second game, 4-1. In the first game Matt Clement pitched a complete game two-hitter, giving up two walks and six strikeouts. Rod Getz pitched six innings, giving up four hits and one run to Clinton.

Victor Hurtado pitched eight innings, allowing three hits in a win over the Beloit Snappers on May 16. He walked one and struck out seven. In the game the Cougars only had three hits, which included two triples, one by Amaury Garcia and one by Steve Goodell. The offense was helped by two stolen bases by Garcia, and one by Randy Winn. Gary Santoro pitched a one-hit ninth to seal the win.

Shannon Stephens pitched eight innings of four-hit ball, he gave up one run and two walks. Shannon struck out 12 Lumberkings on June 24. The Cougars won the game, 4-1. Randy Winn, Joe Funaro, Steve Goodell, and Sommer McCartney all had doubles in the game.

Ryan Dempster started against the Wisconsin Timber Rattlers on September 1 in Appleton. He lasted five innings, before going out of the game with three runs and five hits. The game

would be decided on a home run by David Arias, now known as David Ortiz, in the eighth inning to give the Rattlers an 8-5 win.

The 1997 Cougars would make it to the last game of the championship round against the Lansing Lugnuts. They lost after taking a 2-1 series lead, but they just couldn't win that one last game. The Cougars finished 25 games behind the West Michigan Whitecaps, who won an amazing 92 games and led the league by 20 games. Cougar hitting and pitching were in the middle of the pack throughout the year, but the defense led the league. Tyrone Horne was tenth in the league in hitting. Brent Billingsley was sixth in the league in pitching. Julio Ramirez, and Tyrone Horne were named to the post season all-star team. Ramirez was also named the sixth best prospect in the league. Scott Podsednik led the league in games and at-bats. Jason Garret led in sacrifice flies. Horne led in walks, intentional walks, and on-base percentage.

The '97 team had the likes of Roosevelt Brown, Horne, Jay Jones, Scott Podsednik, Julio Ramirez, Ryan Robertson, Hector Almonte, Brent Billingsley, Gary Knotts, Nelson Lara, Tim McClaskey, Bobby Rodgers, and Martin Sanchez.

David Borkowski, of West Michigan, pitched a no-hitter against the Cougars on April 20. He pitched a complete game, walking two and striking out six. The Cougars lost, 6-0.

Brent Billingsley pitched eight great innings against the Clinton Lumberkings on May 14. He gave up four hits and three walks. Brent struck out nine. Martin Sanchez would pitch the ninth for his seventh save. The Cougars won, 1-0, on Joe Aversa driving in Scott Podsednik in the bottom of the eighth.

Aaron Cames pitched a no-hitter against Peoria on August 24. He walked three and struck out 14. The Cougars won, 1-0, and Jason Alaimo scored the one run. The game took one hour and 55 minutes.

Billingsley pitched a complete game, giving up five hits and one run. The Cougars won 2-1 on August 26 against the Fort Wayne Wizards. He gave up his first hit in the third inning and the only run in the fourth. Jacob Patterson hit a one-out triple to right. Chad Moeller then singled to center to score Patterson. Between the fourth and the ninth, Billingsley retired 14 in a row. Horne and Robertson scored the two runs. Jay Jones and Joe Aversa batted in the runs. Billingsley didn't walk anyone and struck out eight.

The Cougars of 1998 were talented and would send several members to the majors, but they ended the season by missing the playoffs, with a record three games below five hundred, 14 games behind West Michigan. Matt Erickson was third in the league in hitting, with Ross Gload seventh. A.J. Burnett finished second in the league in pitching. Gload, Erickson, and Quincy Foster would be named to the postseason all-star team. Burnett was named the fourth best prospect in the league. Raul Franco led the league in at-bats. Gload led in doubles. Alex Melconian led in being hit by a pitch 28 times. Foster led the league with 73 stolen bases. Erickson led in on-base percentage.

Matt Erickson, Quincy Foster, Ross Gload, Brandon Harper, Drew Niles, Brett Roneberg, Jose Santos, and Kelley Washington made up the stars on the offensive side. Hector Almonte, A.J. Burnett, Scott Comer, Scott Henderson, Gary Knotts, Michael Marriott, Tim McClaskey, Nick Rizzo, and Michael Tejera made up a good pitching staff.

Opening day of '98, the Cougars had their top prospect, Aaron Akin, versus the Peoria Chiefs top prospect, Rick Ankiel. Ankiel pitched five one-hit innings, walking three and striking out six in his pro debut. Akin made it through four innings, giving up six hits and five runs. The Cougars would lose the game, which was Ankiel's pro debut.

The next day Michael Tejera pitched very well in his first start, again against the Chiefs. He got the win, going six innings and giving up two hits.

An eight-run bottom of the eighth helped the Cougars beat the Wisconsin Timber Rattlers on April 28. The score was tied at two going into the inning. Three walks and a hit-by-pitch really helped. Also, Matt Erickson had a two-run double, Jorge Bautista had a run-scoring single, and Foster had a two-run single; all this helped put eight runs on the board. Gary Knotts held

with six innings, giving up four hits and two runs. Nick Rizzo and Hector Almonte put up zeros the rest of the way.

The Cougars won a 1-0 game in Lansing on May 21. The only run of the game came across in the sixth when Ross Gload singled home Matt Erickson. Michael Marriott took it from there and pitched six innings, giving up only two hits. Scott Henderson and Hector Almonte combined for three shutout innings for the win.

A.J. Burnett made his first Cougars appearance on May 25, 1998, against Quad City. The Cougars won the game, 1-0. A.J. retired the first ten he faced, then gave up a walk, got the eleventh out, then hit a batter, and then got an out to end the fourth inning. He gave up a lead off double to Scott Chapman in the fifth. It was a great game as the Cougars scored the only run of the game in the bottom of the tenth inning. Brett Roneberg and Alex Melconian led off with infield hits. Two outs later, Israel Reynoso singled to right to drive home Roneberg to win the game.

The very next day the Cougars would have to score three times in the bottom of the ninth to pull out a 6-5 win over the Quad City River Bandits. The Bandits scored two runs in the eighth inning to take a 5-3 lead. Erickson led off with a walk. Gload then reached on an infield single. Brett Roneberg put down the sacrifice bunt to move the runners along. Melconian was then hit by a pitch to load the bases. Rhodney Donaldson reached on a fielder's choice, Gload was out at third, and Erickson scored. Brandon Harper then hit a triple to center to score Melconian and Donaldson to win the game.

Burnett had another great game at Peoria on June 14. He worked into the seventh inning, getting his third win. He gave up one hit and walked four. A.J. struck out 12. The Cougars would win the game,1-0, with a run in the fifth inning. Brandon Harper led off with a double to center. Melconian put down a bunt to move him to third. Matt Schnable hit a sacrifice fly to score him.

Another 12 strikeouts this time in seven innings for A.J. as the Cougars would beat South Bend, 8-3, on June 21. Burnett gave up one hit in his outing. The Silver Hawks got three runs when Abraham Nunez hit a three-run homer in the ninth off of Hector Henriquez.

Winning 1-0 against your rival the Beloit Snappers is fun, but doing it in 12 innings is even better. That is what happened on June 30. Brett Roneberg led it off with a walk. Bautista bunted him over to second. Kelley Washington then singled to short. Foster was intentionally walked to load the bases. Raul Franco then singled to short to score Roneberg to win the game.

Geoff Goetz pitched for the Cougars in 1998 and 1999. He came to the Marlins in the trade that brought Mike Piazza to the Mets. In 1998, he went 1-4 with a 1.64 ERA in nine games. In 1999, he went 5-3 with a 4.26 ERA in 16 games. He spent three season in Double-A Portland before arm injuries derailed his career. He is currently in the New York Yankee farm system. (Photo by Alan Malamut.)

Hector Henriquez pitched for the Cougars in 1998 and 1999 out of the rotation. He went 0-5 with a 5.28 ERA in 10 games in '98. In 1999, he went 2-5 with a 7.59 ERA in 14 games. He also pitched for the Cougars out of the bullpen in 2000, he went 5-5 with a 5.68 ERA in 50 games. He spent the 2001 season in Brevard County. (Photo by Alan Malamut.)

Nelson Lara pitched for the Cougars from 1997 to 1999. He went 1-2 with a 3.99 ERA in 29 games in '97 with three saves. In 1998, he went 2-2 with a 6.14 ERA in ten games. He spent the '99 season in the bullpen going 3-2 with a 6.06 ERA in 46 games. He spent the 2000 season in Portland and Brevard County. He was traded to the Red Sox in 2001. Six months later he was released by the Red Sox and the Reds signed him; he lasted a month with Cincinnati in the minors. (Photo by Alan Malamut.)

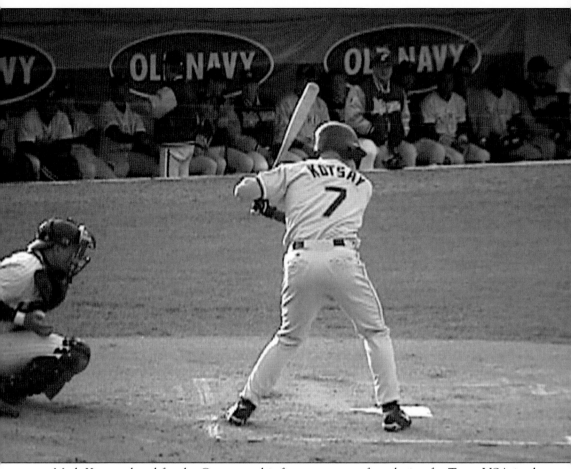

Mark Kotsay played for the Cougars as his first pro team, after playing for Team USA in the 1996 Olympics. He was the Marlins first round pick in '96. In Kane County he hit .283 in 17 games with two homers. He quickly moved to Double-A Portland for '97 where he hit .306 and made his major league debut later that season. He spent the next three seasons in Florida. The Marlins traded him to San Diego for Matt Clement just before the 2001 season. He spent three and a half season in San Diego before being traded to Oakland in 2003. Mark was on the Double-A All-Star Team in '97. The photo is from when the Marlins played an exhibition game against the Cougars in 1999. (Photo by Alan Malamut.)

Jose Santos played for the Cougars in 1998 and 1999. Before that he was traded by the Rangers to the Marlins for Todd Zeile halfway through the '98 season, and was sent by the Marlins to Kane County. He finished the '98 season hitting .188 in 32 games with two homers. In '99 he had a great year, hitting .270 in 128 games, and he tied the club record for homers in a season with 19. After his season and a half in Kane County he spent two seasons in Brevard County where in his best season (2001) he hit .265 with 18 homers. He went to Double-A Portland in 2002 and hit .210. (Photos by Alan Malamut.)

A.J. Burnett pitched for the Cougars (top) for most of the 1998 season and left here with the strikeout record for the Cougars. He went 10-4 with a 1.97 ERA in 20 games. He had 186 strikeouts in 119 innings. Before he came to the Marlins he pitched three seasons in the low minors for the Mets. He was traded from the Mets for Al Leiter. After Kane County he went to Double-A Portland (bottom) where he went 6-12 with a 5.52 ERA in 26 games. He was called up to the majors late in the year and went 4-2 with a 3.48 ERA. In 2000, he went 3-7 with a 4.79 ERA in 13 games for the Fish. The next year he went 12-9 with a 3.30 ERA in 31 games. In 2003, he blew out his arm and had to have Tommy John surgery. In 2002, he pitched a no-hitter in San Diego, while walking eight Padres. (Photos by Alan Malamut.)

Hector Almonte spent a year and a half as the closer for the Cougars. In 1997 he went 0-1 with a 3.86 ERA with one save. In '98 he went 1-5 with a 3.95 ERA with 21 saves. He made saving games for the Cougars hard to watch, but fun in the end. He went to Double-A Portland in 99 and had 23 saves. Late in the season he was called up to the Marlins and pitched in 15 games. The next season he went 0-4 with an 11.17 ERA in 18 games at Triple-A Calgary. He started the 2001 season in Calgary and went 0-0 with a 8.39 ERA in 18 games. He then signed with Yomiuri of the Japanese league. He spent two years over in Japan and had some success. In 2003, he pitched in Triple-A Pawtucket and went 3-0 with a 1.73 ERA in 21 games, and was called up to Boston, where he went 0-1 with an 8.22 ERA in seven games, and was released. Hector signed with Montreal and moved into their bullpen. (Photos by (top) Alan Malamut / (bottom) Pam Rasmussen.)

Brandon Harper spent the 1998 season in Kane County. He hit .231 in 113 games behind the plate. After that he went to Double-A Portland and high Single-A Brevard County. He was injured during the 2002 season and then spent the '03 season in Double-A Carolina where he hit .241 in 67 games. He signed as a free agent with Detroit and was assigned to Double-A Erie, where he is seen here, and then moved to Triple-A Toledo for some of the 2004 season. (Photo by Alan Malamut.)

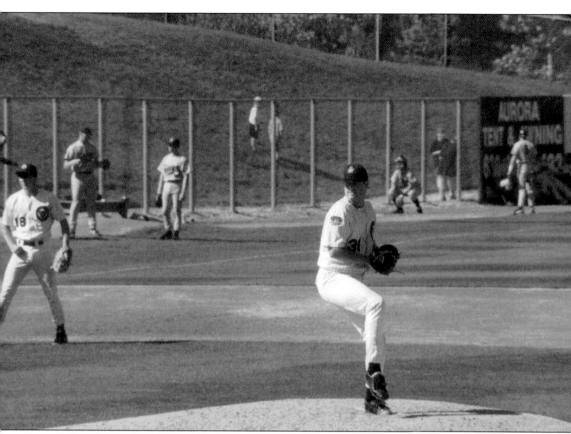

Brent Billingsley pitched very well for the Cougars in 1997. He went 14-7 with a 3.01 ERA in 26 games and he had three complete games. He moved to Portland the next year and went 6-13 with a 3.74 ERA in 28 games. In 1999, he made his major league debut with the Marlins and went 0-0 with a 16.43 ERA in eight games. He was then waived and picked up by Montreal. In Triple-A Ottawa he went 8-9 with a 5.66 ERA in 2000. Over the next two years he would pitch for both Double-A Harrisburg and Ottawa in the Expos system, and not really pitching all too well. In 2003, he pitched with Double-A Reading and went 0-1 with a 10.03 ERA in four games before being released in late April. (Photo by David Malamut.)

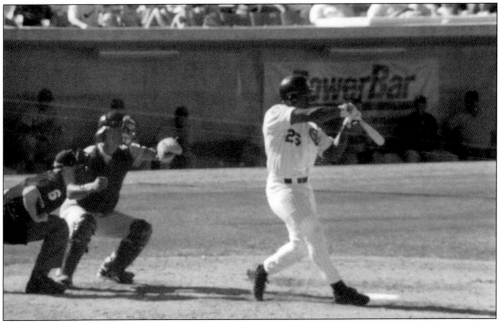

Roosevelt Brown played for the Cougars in 1996 and 1997 after being traded to the Marlins in the middle of the '96 season in a trade for Terry Pendleton. He hit .150 in 11 games in '96. In 1997, he hit .237 in 61 games with four homers. After the '97 season he was selected by the Cubs in the rule five draft and played at high Single-A Daytona, Double-A West Tennessee, and Triple-A Iowa. He hit .358 in 74 games at Iowa. He would make his major league debut for the Cubs in 1999, and hit .219 in 33 games. He played for the Cubs the next three seasons, before being released after the 2002 season. (Photos by Alan Malamut.)

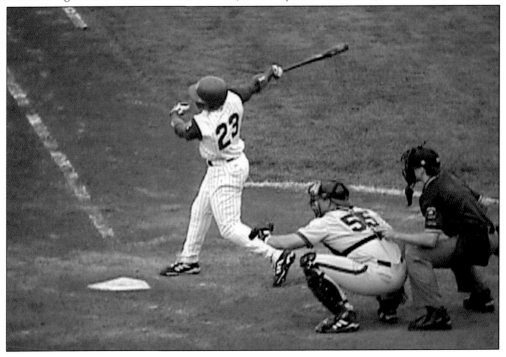

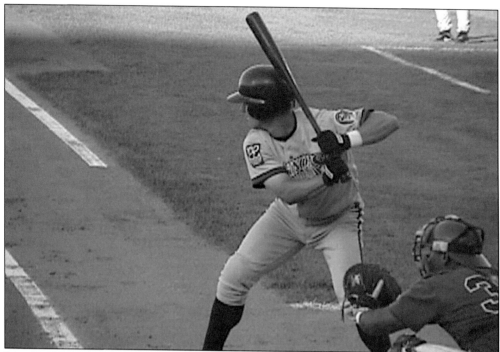

Matt Erickson played for the Cougars in 1998 and hit .324 in 124 games at third base. He had 143 hits and had ten more walks than strikeouts. After playing for the Cougars he went to Portland for two years. In 2000, he hit .301 in 100 games. He spent the next two years playing for Calgary. In 2003, he played for Albuquerque and hit .342 in 98 games. In six of his eight years in pro ball he has had over 100 hits. In 2004, he played for the Indianapolis Indians, and later in the year he made his major league debut with the Milwaukee Brewers. (Photos by Alan Malamut .)

Quincy Foster played for the Cougars in 1998 and hit .253 in 134 games, while stealing 73 bases. After the Cougars he went to high Single-A Brevard County were he hit .294 in 134 games and stole 56 bases in 1999. In 2000, he hit .310 for Double-A Portland in 65 games. He spent most of the next two years in Portland, In May of 2002, he was traded to Montreal, where he was assigned to Double-A Harrisburg. He hit .300 in 57 games for them. In 2003, he hit .292 in 88 games for Harrisburg. He was a Midwest League All-Star in '98, and a Florida State League All-Star in '99. His final year, 2004, was spent in the Independent Atlantic League. (Photos by Alan Malamut.)

Ross Gload played for the Cougars in 1998. He hit .313 in 132 games with 12 homers. He was the Howe Sportsdata Star of Stars, in the 1998 Midwest League All-Star Game. After the Cougars he went to high Single-A Brevard County and hit .298 in 133 games. While hitting .284 for Double-A Portland in 2000, he was traded to the Cubs for Henry Rodriguez. Ross was sent to Triple-A Iowa where he hit .404 in 28 games with 16 homers. That earned him a trip to Wrigley for 18 games. He spent the 2001 season back in Iowa were he hit .297 in 133 games with 15 homers. He was waived by the Cubs and claimed by Colorado, and spent most of the 2002 season in Triple-A Colorado Springs. He hit .314 in 104 games with 16 homers. Ross did make it back to the majors, this time with the Rockies for 26 games. Before the 2003 season he was traded to the White Sox, and would play in Triple-A Charlotte. He hit .315 in 133 games with 18 homers. Gload spent the 2004 season with the White Sox, mainly coming off the bench, but playing well. (Photos by (top) Alan Malamut / (bottom) Pam Ransmussen.)

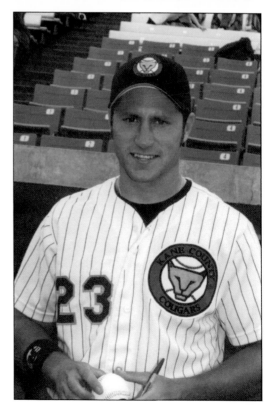

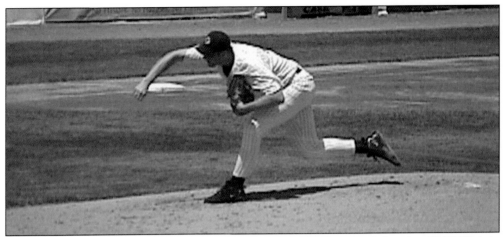

Gary Knotts played for the Cougars in 1997 and 1998. In '97 he went 1-1 with a 13.05 ERA in seven games. In '98 he went 8-8 with a 3.87 ERA in 27 games. He threw three complete games. After the Cougars, he went to Brevard County in '99, going 9-6 with a 4.60 ERA in 16 games, and pitching three more complete games. He went up to Portland and went 6-3 with a 3.75 ERA. Gary spent the 2000 season in Portland again, this time he went 9-8 with a 4.66 ERA. After a so-so year at Triple-A Calgary he went up to the majors and went 0-1 with a 6.00 ERA in two games. The 2002 season was another one which he spent in both Florida and Calgary and combined to go 8-4 in 80 games out of the bullpen. In January of 2003, he was traded with Nate Robertson and Rob Henkel to Detroit for Mark Redman. He pitched at Detroit and Triple-A Toledo, and combined to go 7-14 in 33 games. (Photo by Alan Malamut.)

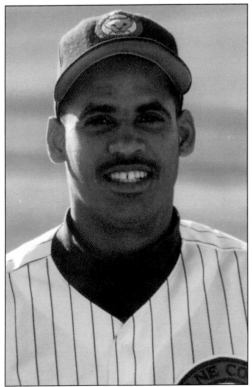

Julio Ramirez played for the Cougars in 1997 and hit .255 in 99 games with 14 homers. He went to high Single-A Brevard County in 98 where he hit .279 in 135 games with 13 homers. Julio played in Double-A Portland in '99, where he hit .261 in 138 games. He also made his major league debut and hit .143 in 15 games. The next year he hit .266 in Triple-A Calgary. The Marlins traded him to the White Sox after the season. He played in Triple-A Charlotte and in Chicago. In Chicago he hit .081 in 22 games. The Angels signed him and assigned him to Triple-A Salt Lake where he hit .273 in 39 games. He also played in Anaheim over the next two years. Julio was a 1997 Midwest League All-Star, a Florida State League All-Star in 1998, and an Eastern League All-Star in 1999. (Photo by Pam Rasmussen.)

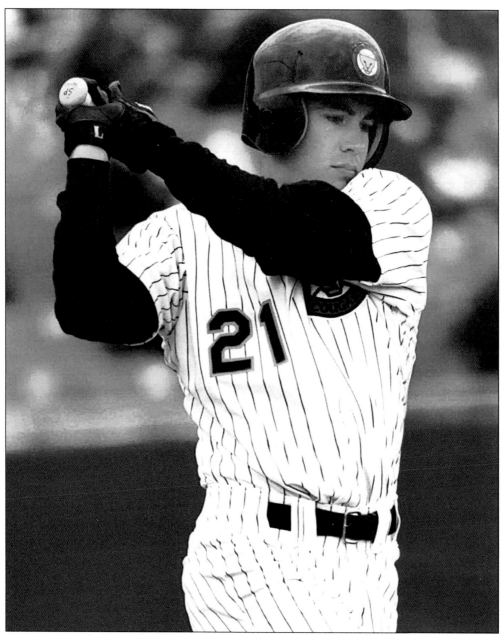

Scott Podsednik played for the Cougars in 1997 and hit .277 in 135 games. He was traded to the Marlins by the Rangers for Bobby Witt. After the season he was selected by Texas in the rule five draft, they sent him to high Single-A Charlotte in Florida and he hit .285 in 81 games. He continued to climb the ladder in the Rangers system until 2001. He signed as a free agent with the Seattle Mariners and hit .290 with Tacoma in 66 games. Podsednik made his major league debut that year and played in five games with the big club. The next year he spent time at both Triple-A Tacoma and in Seattle. The Mariners waived him in October of 2002 and the Brewers signed him. In 2003 he hit .314 in 154 games and stole 43 bases for the Brew Crew. He was in the running for Rookie of the Year in the National League.

Ryan Dempster pitched for the Cougars in four games in 1996. He went 2-1 with a 2.73 ERA. He had one complete game in 1996, and opposing batters hit .202 against him. He was traded by the Texas Rangers in August for John Burkett. In 1997 he played in high Single-A Brevard County and went 10-9 with a 4.90 ERA in 28 games. In 1998 he pitched for Double-A Portland, Triple-A Charlotte and Florida and went 8-9 in 26 games. The next four years he spent with the Marlins and went 41-38. He was traded to the Cincinnati Reds in July 2002, and went 5-5 with a 6.19 ERA. In the 2003 season he split time between Cincinnati and Triple-A Louisville and went 4-8 in 24 games. He blew out his elbow and had Tommy John surgery. Dempster then signed with the Cubs and in 2004 eventually made it to the Cubs bullpen and pitched well. (Photo by Pam Rasmussen.)

Michael Tejera pitched for the Cougars for ten games in 1998. He went 6-1 with a 2.77 ERA. He was moved directly to Double-A Portland and went 9-5 with a 4.11 ERA in 18 games, with two complete games. Tejera went 13-4 with a 2.62 ERA in 25 games in Portland in '99. He also spent time in Triple-A Calgary and made his major league debut with the Marlins that year. After spending the 2000 season out with injuries, he played in Portland for 25 games and went 9-8 with a 3.57 ERA. Back to the majors in 2002, he went 8-8 with a 4.45 ERA and then spent the next couple of years in Miami. (Photo by Alan Malamut.)

Tyrone Horne played for the Cougars in 1997. He started his career way back in 1989 in the Expos system. He played in Rockford in 1992, and hit .279 in 129 games. Tyrone topped out at Double-A Harrisburg in 93-95, In Kane County he hit .306 in 133 games. He tied the home run record with 21. He also was walked 18 times intentionally. The next year he played for Arkansas and hit .312 with 37 homers in 123 games, including four homers in one game. (Photo by Pam Rasmussen.)

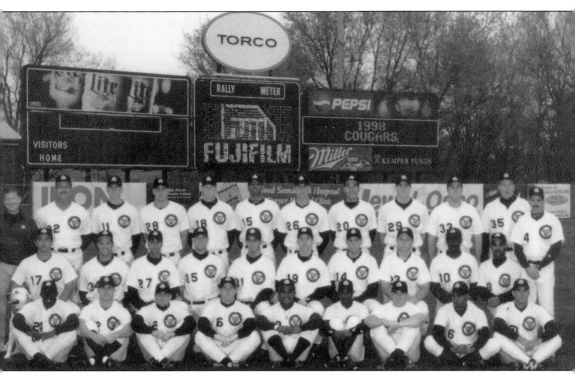

The 1998 Kane County Cougars, pictured from left to right, are (front row) 24, Rhodney Donaldson (OF), 12, Matt Erickson (3B), 22, Matt Schnabel (OF), 16, Nick Rizzo (P), 8, Ismael Reynoso (IF), 1, Raul Franco (2B), 21, Alex Melconian (OF), 6, Israel Polonia (IF), 30, Michael Tejera (P); (middle row) 17, Travis Borges (P), 34, Hector Almonte (P), 27, Derek Santiago (P), 25, Aaron Akin (P), 31, Tim McClaskey (P), 19, Brett Roneberg (OF), 14, Matt Levan (P), 23, Ross Gload (1B), 10, Quincy Foster (OF), 13, Jorge Bautista (IF/OF/P); (back row) 32, Steve Luebber (PC), 11, Billy Putnicki (P), 28, Michael Marriott (P), 18, Scott Henderson (P), 15, Cory Lima (P), 26, Brandon Harper (C), 20, Steve Gagliano (P), 29, Gary Knotts (P), 33, Travis Hunter (IF), 35, Matt Winters (HC), and 4, Juan Bustabad (MG).

The previous two seasons' teams had some good talent, too. Nate Rolison played for the Cougars in 1996 and hit .243 in 131 games, with 14 homers. After that he moved to high Single-A Brevard County, and then spent two years in Double-A Portland. He hit .277 and .299 in Portland, before moving on to Triple-A Calgary in 2000. In Calgary he hit .330 in 123 games with 23 homers, and was named Pacific Coast League Rookie of the Year. Rolison made his major league debut that year with the Marlins but hit only .077. he's gone on to play at Triple-A Tacoma, and then Triple-A Columbus.

Randy Winn played for the Cougars in 1996 and hit .270 in 130 games. He moved up to high Single-A Brevard County for 1997 and hit .315, then to Double-A Portland and hit .292 where he hit his first professional homer. He was selected by Tampa Bay in the expansion draft and sent to Triple-A Durham where he hit .285. Winn made his major league debut with Tampa in '98, hitting .278 in 109 games. In 2002, he was an American League All-Star. He was traded to Seattle in 2003 and hit .295 for the Mariners in 157 games.

Tim McClaskey played for the Cougars in 1997 and 1998. He spent 18 games in '97 going 2-1 with a 3.16 ERA. He started two games and had one save. He spent the entire 1998 season in Kane County and went 5-2 with a 4.26 ERA in 34 games. He started twice and saved two games. After the '98 season, he was selected by the Mariners in the rule five draft. He spent 30 games in high Single-A Lancaster and went 3-3 with a 6.36 ERA. He went to Double-A New Haven for four games. After that he was released by the Mariners, resigned by the Marlins and sent to high Single-A Brevard County. In 2000, he went 7-4 with 2.25 ERA in 46 games. He had 13 saves. He spent the 2001 season in Brevard County, going 3-1 with a 0.88 ERA in 26 games. He had 14 saves. He pitched in 31 innings and had 41 strikeouts. He was promoted to Double-A Portland were he was 2-2, with a 2.86 ERA in 37 games. Tim was signed by the Athletics in 2002 and sent to Double-A Midland where he got pounded. He went back down to high Single-A Visalia and went 4-6, with a 4.31 ERA in 19 games. He had 17 starts with two complete games. He also spent some time that year in Triple-A Sacramento for two games. He would sign and was released by the Tigers before the 2003 season. He signed with Springfield of the Central League. He had a great year there, going 6-2 with a .161 ERA in eight games. He had seven complete games. That got him signed by Houston, and sent to Double-A Round Rock. He went 5-4, with a 4.66 ERA in 15 games with one save. (Photo by Alan Malamut.)

FIVE

1999–2000

The 1999 season, the Cougars would get to the semi-finals in the playoffs and lose to the Burlington Bees in a painful game three at Elfstrom Stadium. The Cougars had the best record in the league by two games, they were 19 games above five hundred, and somehow finished with the best record even though they finished second in their division in both halves of the season.

Hitting, the Cougars finished third in the league, the pitching finished fourth, and they did lead the league in fielding. Wes Anderson would rank eighth in the league in pitching. David Noyce would be a post season all star. They had a collection of good players, including, Chris Aguila, Jeff Bailey, Jesus Medrano, Matt Padgett, Brett Roneberg, Jose Santos, Matt Treanor and Derek Wathan. The pitchers included Wes Anderson, Jorge Cordova, Blaine Neal, David Noyce, Kevin Olsen, Nate Robertson, Joe Sergent, and Claudio Vargas. The Cougars had the manager of the year in Rick Renteria.

The Cougars won, 6-5, in ten innings on April 17 at Beloit. Willy Hill and Jesus Medrano had three hits apiece. Derek Wathan led off the tenth with a single to right. Chris Aguila moved him over to second. Hill then singled to right to score Wathan to give the Cougars the lead. The Snappers had a chance to win in the bottom of the tenth. With one out Scott Kirby singled to right. Bobby Darula then was hit by a pitch. Al Morrow singled to short to load the bases with one out. Rich Mackiewitz lined out to left for the second out. Kirby tried to tag up and score on the liner and would be out on a throw from left fielder Chris Aguila to win the game.

Kane County scored four runs in the top of the ninth inning against the Peoria Chiefs to tie the game at nine on May 4. Chris Aguila had hit a solo homer in the second inning to give the Cougars a 4-1 lead. In the ninth, Heath Kelly led off with a walk. Brett Roneberg then hit a double to right to score Kelly. The Chiefs then made a pitching change, and Jose Santos walked. David Callahan reached on a fielder's choice, Santos was out, but Roneberg moved to third. Matt Treanor singled to center to score Roneberg. Matt Frick then followed with a double to center to score both Callahan and Treanor. The Chiefs scored the winning run in the bottom of the ninth against Brad Farizo. Jovany Williams led off by being hit by a pitch, Darren

Dyt then reached on a fielder's choice, with Williams being out at second. Brandon Folkers singled to center. Joe Secoda then reached on a fielder's choice with Dyt being out a third. Jason Bowers singled to right to score Folkers. Earlier in the game, Folkers had hit a grand slam in an eight-run seventh, which also included four walks and a triple.

The Cougars beat the Cedar Rapids Kernels 14-13, on May 8. Together, the two teams combined for 45 hits and four errors. The game would go 14 innings, only one run scored in extra innings. Brett Roneberg led off the fourteenth with a double to left. Jose Santos singled to third, with Roneberg getting to third. A passed ball by Jason Hill would allow Roneberg to score to finally end the game. The game took 4 hours and 21 minutes.

The very next day the Cougars again went to extra innings with Cedar Rapids, this time only eleven, and the Cougars would again win. Derek Wathan led off with a double to right. Chris Aguila bunted him to third. One out later, Heath Kelly was intentionally walked. Brett Roneberg then singled to left to bring home Wathan for the game-winning run.

Less than a week later the Cougars would go to 15 innings to beat the Burlington Bees, 1-0. The Bees starter Geromino Mendoza pitched nine innings of three-hit ball. In the game the Bees would be thrown out at the plate twice. In the bottom of the fifteenth, Jose Santos would hit a leadoff homer to win the game.

The next day the Marlins came to town for an exhibition game against the Cougars. Florida would win, 3-0. Luis Castillo, Alex Gonzalez, Mark Kotsay, Todd Dunwoody, Dave Berg, Mike Redmond, and future Cougars Luis Ugueto, Chip Ambres, Jeff Bailey, Gustavo Lopez, Blaine Neal, and John Seaman all played for the Marlins.

The following day Burlington had to score three runs in the bottom of the ninth to beat the Cougars, 4-3. Mario Valenzuela led off the inning with a single to right. Corey Jenkins then followed with a walk. Rolando Garza moved the runners along. Jason Fennel pitch hit, and singled to center to score both runs; an error on Hill would allow Fennell to move to second. One out later, Luis Saurez walked. Ender Gonzalez then singled to right to score Fennell for the win.

Claudio Vargas pitched a complete game two-hitter on June 4, 1999, in Cedar Rapids. He gave up only one run. Brett Roneberg hit a homer. Wes Anderson pitched a complete game four-hitter on June 11, striking out eleven at Peoria. The Cougars won, 4-0, scoring all four runs against Steve Stemle.

David Noyce pitched a complete game three-hitter at West Michigan on July 1. He struck out seven in the 1-0 win. The Cougars scored their only run in the sixth on a sacrifice fly.

They won again, 1-0, in Rockford on July 10. In the bottom of the ninth, with two outs, Jesus Medrano singled back to the mound. Medrano stole second, and Chris Aguila was intentionally walked. Willy Hill then walked, which loaded the bases. The Reds then made a pitching change, and Derek Wathan walked to bring home Medrano to win the game.

Four runs in the bottom of the ninth by the Clinton Lumberkings took away a win from the Cougars on July 26, the final score, 7-6. The Cougars scored three runs in the top of the ninth. David Callahan hit a two-run homer and a sacrifice fly to score Wathan, giving the Cougars the lead. Nelson Lara could not get an out in the bottom of the ninth. He hit the first batter, walked the second, and then gave up two run-scoring singles. Then with runners on first and second and nobody out, Lara uncorked a wild pitch. He then had to intentionally walk the number nine hitter to load the bases. The leadoff man then walked to force in the tying run. A suicide squeeze followed to scor the final run to give the Kings the win.

The Cougars would have a fun run in the playoffs, after losing the first game in Quad City in the first round, they came back home and won the second in the bottom of the ninth. Brett Roneberg hit a two-out solo shot onto the bleachers in center.

In game two of the semi finals the Burlington pitcher, named Mark Buerhle, pitched into the eighth inning to get the win over the Cougars and even the series up at one. The next day was bombs away for the Bees, as their first baseman Eric Battersby hit four homers and drove in six to beat the Cougars, and end their season.

The 2000 season was highlighted by another playoff run, even though it would end in the first round. The Cougars finished fourth in overall record, 13 and a half games behind West Michigan. They were nine games above five hundred.

They were near the bottom in hitting, but toward the top in pitching, and again would lead the league in defense. Todd Moser was sixth in the league in pitching. Josh Beckett was named prospect of the year in the league. Marc Sauer unfortunately led the league in homers and hits allowed.

The Cougars did have some talented players. Chip Ambres, Kevin Hooper, Matt Padgett, Luis Ugueto, and Kelley Washington led the team in the in the batters box. On the mound, Josh Beckett was the best pitcher. Brandon Bowe, Jorge Cordova, Chris Key, Gustavo Lopez, Bryan Moore, Todd Moser, Nate Robertson, Marc Sauer, Steve Sawyer, and Joe Sergent each had good years.

Josh Beckett was the opening day starter for the Cougars against Peoria on April 6. He went four innings, giving up four hits and one run in his first two innings. After that he struck out four in his last two innings. His one run against came off of a double by Albert Pujols, who drove in Johnny Hernandez in the first inning. Beckett went five innings in his next start, against Wisconsin on April 12. He walked three and would not give up a run, thanks to a good throw from right fielder Kevin Perkins to cut down a runner at home in the first inning. The Cougars lost the game, 6-1. Josh struck out five Timber Rattlers.

Beckett got his first professional win on April 16, 2000, or more like May 30, since it was in the completion of a suspended game against Burlington in which he came on after it was restarted and pitched two innings to get the win.

In game one of a double header in Wisconsin the Cougars were no-hit by Rattler pitcher J.J. Putz. He went seven innings, giving up one run and five walks. Wisconsin won, 6-1.

Kane County beat Clinton 5-4 in 14 innings, after surviving a leadoff double in the top of the fourteenth by Omar Hurtado. Cougar pitcher Hector Henriquez struck out the next hitter. Then he got the next to fly out. Lumberking pitcher Mike Neu then got wild in the bottom of the inning. Chip Ambres led off with a walk. He was bunted over to second by Kevin Hooper. Scott Goodman was intentionally walked. Matt Frick was then walked to load the bases. David Callahan came up, but Neu threw a wild pitch which allowed Ambres to score to win the game.

The Cougars were no-hit again on June 10, 2000, this time in West Michigan, by Tommy Marx who beat the Cougars, 8-0, He walked six and struck out ten. Three days later the Cougars would be no-hit again by West Michigan pitchers. Calvin Chipperfield pulled the trick in the second game of a double header, winning 2-0. He walked four and struck out ten Cougars.

The Cougars hosted the Midwest League All-Star Game on June 20. Matt Padgett would be named MVP after getting four hits in the game. Matt Frick, Kevin Hooper, Todd Moser, and Bryan Moore also played. Moore got the win.

On July 14, against the Michigan Battle Cats, the Cougars lost, 1-0. Derek Stanford of the Cats pitched a complete game one-hitter, walking one and striking out ten Cougars. Josh Beckett started for the Cougars and went six innings, giving up three hits and striking out six. The game would be decided on a sacrifice fly in the top of the ninth by Alejandro Vazquez to score Jon Topolski for the win.

It was not until July 24 that Beckett got his second and final win with the Cougars. He beat the Fort Wayne Wizards, 2-1. Beckett pitched into the eighth inning, giving up two hits and one run. Bryan Moore got his fifteenth save.

And another three seasons of Cougar baseball had brought some serious major league prospects to Kane County fans.

The Josh Becket bobblehead giveaway in 2004 was a big hit among Cougar fans who remembered his pitching days in Kane County. Beckett played for, and made his professional debut with, the Cougars in 2000. Due to injuries he would only pitch in 13 games and have a record of 2-3 with a 2.12 ERA in 59 innings. After that he made two stops in the minors the next season, high Single-A Brevard County and Double-A Portland. He went a combined 14-1 in 26 games. He was quickly in a Marlins uniform later in the year. He went 2-2 with a 1.50 ERA in four games with the Fish. The next year he went 6-7 with a 4.10 in 23 games with the Marlins. In 2003, he went 9-8 with a 3.04 ERA in 24 games with the Marlins. It is what Becket did in the playoffs that made his year so unique. He pitched game seven of the World Series, on short rest, in Yankee Stadium, and pitched a complete game, winning the championship. Josh was a first-round pick of the Marlins in 1999, out of high school in Texas. He was named Baseball America Minor Leaguer of the Year in 2001. (Photo by Alan Malamut.)

Josh is seen here throwing from the mound during his stint with the Kane County Cougars in 2000. (Photo by Alan Malamut.)

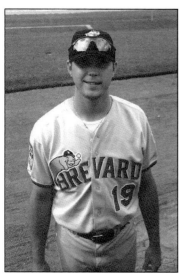 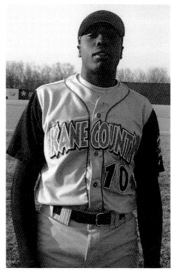

Becket (left), seen here in his 2001 Brevard County uniform, and Dontrelle Willis (right), who played for the Cougars in 2002, never played together in Kane County. But they later became teammates on the 2003 World Series Champion Florida Marlins. (Photo by (left) Dan McQuad and (right) Alan Malamut.)

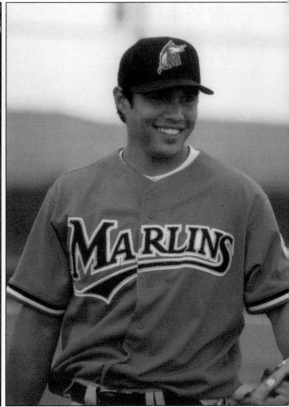

Chris Aguila was a stand out high school hitter; he held the Nevada High School record for homers in a single season. Chris played for the Cougars in 1999 and hit .244 with 15 homers in 122 games. The next two years he spent a lot of time in high Single-A Brevard County, where he hit .241 and .276. In 2001, he spent half a season in Double-A Portland, and in 64 games he hit .257. Aguila spent the 2002 season in Portland hitting .294 with six homers in 130 games. Again in Double-A, this time in Carolina, he hit .320 with 11 homers in 93 games. In 2004, he made it to Triple-A, and was called up to the Marlins for his major league debut. (Photos by (top) Alan Malamut / (bottom) Pam Rasmussen.)

Kevin Hooper was the spark plug second baseman for the Cougars (above) in the 2000 and 2001 seasons. In 2000, he hit .249 in 123 games, he had six triples and three homers. He was sent back to the Cougars to start the 2001 season and hit .292 in 17 games. Then it was off to Double-A Portland (below), were he continued to hit. He went .308 in 117 games with the Seadogs. Hooper would get to Triple-A Calgary in 2002 and hit .288 in 117 games. Again in Triple-A, this time in Albuquerque, he hit .266 in 130 games. After that, in the 2004 season he would spend time in Triple-A with Albuquerque, Omaha, and Columbus. (Photos by Alan Malamut.)

Jeff Bailey caught for the Cougars in 1999. He hit .278 in 76 games with 10 homers. The next couple of years he spent in high Single-A Brevard County and Double-A Portland. After the 2002 season he was traded to Montreal. Bailey was assigned to Double-A Harrisburg, where he hit .282 in 99 games with 13 homers. In 2003, he would return to Harrisburg, but towards the end he would get his first taste of Triple-A ball, in Edmonton. He hit .412 in five games in Edmonton. Jeff signed with the Boston Red Sox in the off-season and played in Double-A Portland in 2004. (Photo by Alan Malamut.)

Jesus Medrano hit .274 in 118 games for the Cougars in 1999. He also stole 42 bases and hit five homers. The next two seasons he spent in high Single-A Brevard County, where in 2001 he hit .251 in 125 games and had 61 steals. He moved on to Double-A Portland for 2002 and hit .297 in 116 games with three triples. Jesus split the 2003 season between Double-A Carolina and Triple-A Albuquerque. After the season he was released by the Marlins and signed by Boston. He spent most of 2004 in Double-A Portland. In 2002 he was an Eastern League all star at second base. (Photos by Alan Malamut.)

Todd Moser pitched for the Cougars in 2000, going 9-5 with a 2.83 ERA in 21 games. He had three complete games. He was injured most of the 2001 season, but came back and pitched for high Single-A Jupiter. He went 7-4 with a 3.59 in 17 games. In 2003 he spent time in both Jupiter and Double-A Carolina and went a combined 9-4 in 23 games. He spent most of the 2004 season in Carolina. Todd was a New York Penn League all-star in 1999, and was named to Baseball Americas short season all start team that year. (Photos by Pam Rasmussen/ Alan Malamut.)

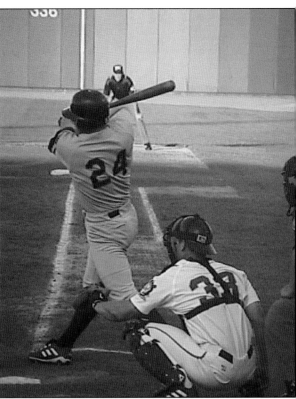

Matt Padgett came to the Cougars during the all-star break in 1999, and would play in 45 games and hit .333 with five homers. This is after staring for the University of Clemson in 1998. He spent the 2000 season in Kane County also, and hitting .233 with 12 homers in 125 games. Matt was named Most Valuable Player of the all-star game in Kane County. In 2001, he hit .293 in 125 games for high Single-A Brevard County. He spent two seasons in Double-A. In 2002, he played for Portland, hitting 16 homers in 117 games. He returned to that level, but this time in Carolina for the 2003 season, and hit .277 with 17 homers in 129 games. In 2004, he played at Triple-A Albuquerque. (Photos by Alan Malamut.)

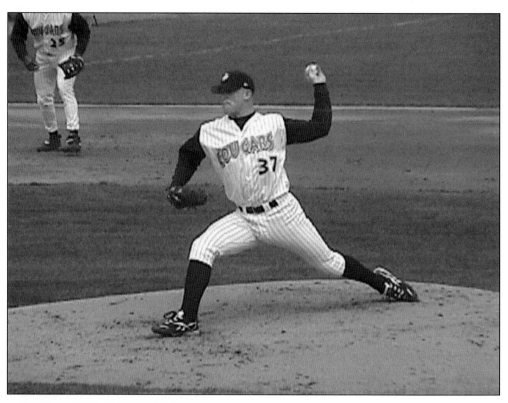

Nate Robertson pitched for the Cougars (above) in 1999 and 2000. During the '99 season he went 6-1 for the Cougars after being drafted that June. He had a 2.29 ERA in eight games with one complete game. In 2000, he went 0-2 with a 5.09 ERA in six games. The bad part is, in that last game, he came off the field holding his elbow and pain etched on his faced. He had just blown out his elbow. In 2001, he played for high Single-A Brevard County and went 11-4 with a 2.88 ERA in 19 games, and had two complete games. After going 10-9 for Double-A Portland (left) in 2002, seeing 27 appearances with three complete games, he was recalled to the Marlins in an emergency start. He would end up 0-1 with an 11.88 ERA in six games with the Fish. The next year he, along with Rob Henkel and Gary Knotts , were traded to the Detroit Tigers. Nate spent the year in Triple-A Toledo and Detroit. In Toledo he went 9-7 with a 3.14 ERA in 24 games. He pitched three complete games, but gave up 14 homers in 155 innings. He also pitched for Detroit and went 1-2 with a 5.44 ERA in eight games. In 2004, he was in the starting rotation for the Tigers and had a good year. (Photos by Alan Malamut.)

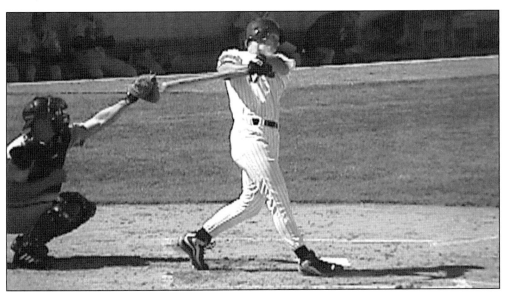

Brett Roneberg played for the Cougars (above) in 1998 and 1999. He hit .271 in 68 games for the Cougars in '98. He had to go on the disabled list and missed the rest of the season because of a back injury. In '99 he hit .288 in 132 games with eight homers. High Single-A Brevard County was his next stop, in 2000, and some of 2001. In 2000, he hit .261 in 125 games. In 2001, he hit .299 in 88 games with eleven homers. He went up to Double-A Portland (below) for 49 games in '01 and hit .262 with five homers. He spent some of the 2002 season injured, but ended up being able to play three games with Triple-A Calgary and hit .400. Brett was traded to Montreal in June and assigned to Double-A Harrisburg. He hit .294 in 63 games with four homers. After the season he signed with Pittsburgh as a free agent and was assigned to Double-A Altoona. Brett played in 125 games and hit .281 with ten homers. After the season he signed with Boston, and was assigned to Double-A Portland. Brett also played in the Olympics for Australia in 2000 and in 2004. (Photos by Alan Malamut.)

Claudio Vargas pitched for Kane County in 99. He went 5-5 with a 3.88 in 19 games with one complete game. The next year he went to high Single-A Brevard County and went 10-5 with a 3.28 in 24 games. He would move up to Double-A Portland and went 1-1 with a 3.60 in three games. Portland would be his destination again in 2001. He went 8-9 with a 4.19 ERA and 17 games. In 2002 he would go 4-11 with a 6.72 ERA in Triple-A Calgary. Vargas was traded to the Expos with Cliff Floyd for Carl Pavano. He would be assigned to Double-A Harrisburg, where he went 2-2 in eight games. He went from Harrisburg to Triple-A Edmonton, then made his major league debut with Montreal and went 6-8 with a 4.34 ERA in 23 games. (Photos by Alan Malamut.)

Matt Treanor has been on a roller coaster ride through the minors. He was selected in the fourth round of the 1994 draft by the Kansas City Royals. He spent the '95 season in Single-A Springfield, and hit .185 in 75 games. In 1996, he played for Single-A Lansing and hit .260 in 119 games. During the next season he was traded to the Marlins and assigned to high Single-A Brevard County. He played there in 1997 and 1998. Treanor spent the '99 season with the Cougars and hit .286 in 86 games with ten homers. Next year it was back to Brevard County, then over to Double-A Portland. He was injured and came back to Kane County for a game and had one hit in his four plate appearances. He walked three times and scored twice. In 2002, he went to Portland and hit .250 in 50 games, then moved up to Triple-A Calgary and hit .284 in 36 games. Triple-A Albuquerque is where he played the 2003 season. He hit .273 in 98 games with eleven homers. In 2004, after ten years in the minors, Matt made his major league debut for the Marlins. (Photos by Alan Malamut / Pam Rasmussen.)

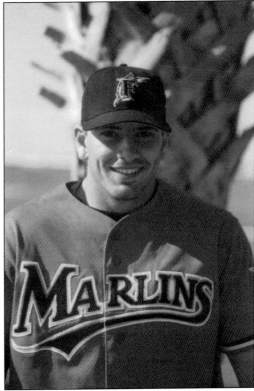

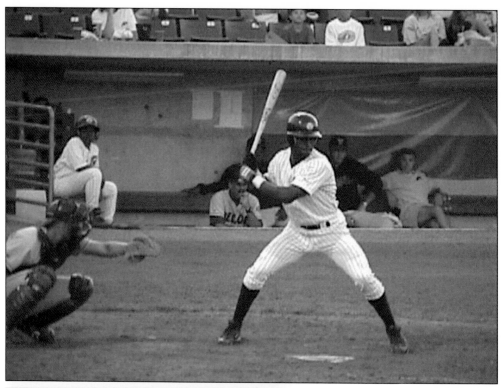

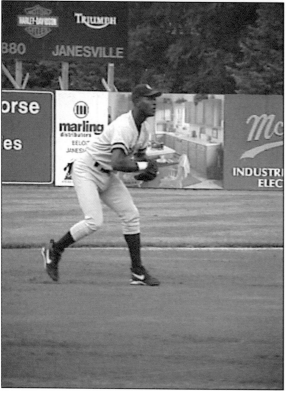

Kelley Washington first came to the Cougars in 1998 as a shortstop. He hit .247 in 65 games. He would spend the next year in high Single-A Brevard County and hit .269 in 57 games. In 2000, he came back to Kane County, but he had filled out a little and now was a third baseman. He hit .205 in 107 games before calling it quits. Kelley went to the University of Tennessee and stared as a wide receiver on the football team. He was drafted by the Cincinnati Bengals, and has been in the National Football League since leaving college. (Photos by Alan Malamut.)

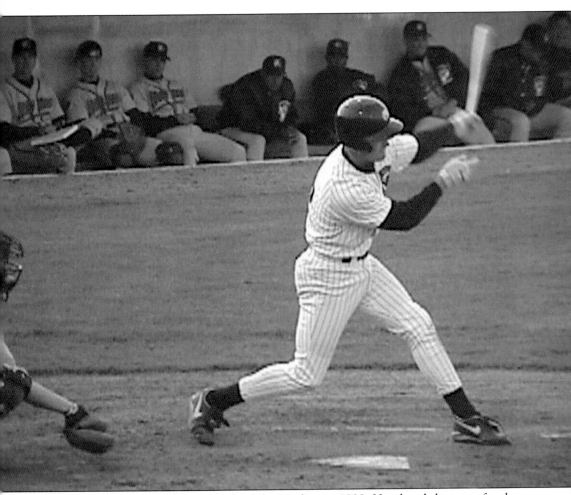

Derek Wathan was a second round pick of the Marlins in 1998. He played shortstop for the Cougars in 1999, hitting .254 in 125 games. After that he moved up to high Single-A Brevard County and Double-A Portland in 2000. In 2001, he was at Portland and hit .252 in 127 games. He hit .280 for Triple-A Calgary in 2002 in 102 games. Wathan has spent time at all positions in the infield, not to mention center field. He spent another season in AAA, this time in Albuquerque, and hit .296 in 116 games. (Photo by Alan Malamut.)

Matt Winters was the hitting coach for the Cougars from 1996 to 2001. He worked very well with the hitters, and always had time for the fans. Matt played in the majors during the '90s and was a legend in Japan for his hitting when he played there. (Photo by Alan Malamut.)

The Florida Marlins came and played the Kane County Cougars on May 13, 2000, in a seven-inning exhibition game in front of 6,556. The Marlins won 3-0. Gus Lopez started for the Marlins, followed by Blaine Neal and John Seamon from the bullpen. With one out in the fifth, Mark Kotsay singled to left. One out later, Todd Dunwoody walked. Preston Wilson singled to left to score Kotsay. With one out in the sixth, Luis Castillo walked. Craig Counsel then singled to right. Alex Gonzalez singled to right to score Castillo. Kotsay then hit a sacrifice fly to center to score Counsell. For the Cougars, Jorge Bautista had a double and a single, and Heath Kelly and Terrence Smalls also had singles.

Chicago Tribune
Presents

KANE COUNTY COUGARS

VS.

FLORIDA MARLINS ™

May 13th 1999
Game Time 6:00 pm

SECTION	ROW	SEAT
5	13	99

PHILIP B. ELFSTROM STADIUM

This is the team photo from 2000. Josh Beckett is #19 in the back row. Several others on this team fought to make it up the farm system. Dave Callahan played first base for the Cougars from 1999 to 2000. In '99 he hit .245 in 124 games with two homers. In 2000, he hit .264 in 131 games with seven homers. He would play the '01 season in high Single-A Brevard County and hit .254 in 123 games with nine homers. After that he was released by the Marlins and would play for New jersey, Sarasota, and St. Paul as he traveled through the minors.

Jorge Cordova pitched for the Cougars in 1999 and 2000. He went 1-0, with a 0.47 ERA in 12 games in 1999, after coming down from high Single-A Brevard County. In 2000, he was 6-7, with a 3.88 ERA in 22 games. He had 15 starts, one complete game and one save. In July he got traded to the Reds, and would be assigned to Clinton were he went 3-2, 4.25 in eight games. The next year he went to Mudville and went 9-8, with a 3.72 ERA in 30 games. He spent 2002 in Stockton, Chattanooga, and Louisville going a combined 9-2 in 51 games, and on to Double-A Erie were he went 1-1, with a 4.53 ERA in 30 games out of the pen.

Francisco (Paco) Ferrand played for the Cougars from 1999 to 2001. He played in 16 games in '99 and hit .255. In 2000, he played in 77 games and hit .251 with 12 homers and six triples. He hit .195 in high Single-A Brevard County in 2001, so was sent back to Kane County, where he would hit .290 in 85 games with six homers.

Brandon Bowe pitched for the Cougars in 2000. He went 7-3, with a 3.73 ERA in 61 games. He had six saves. After that he went to high Single-A Brevard County to start the 2001 season. He went 6-4, with a 1.55 ERA in 42 games and eleven saves. He moved on to Double-A Portland to finish out the season , and spent the 2002 season in Portland again, going 6-4, with a 3.72 ERA in 45 games and four saves.

Luis Ugueto played for the Cougars in 2000, after already having spent 15 games the previous two years in high Single-A Brevard County. He hit .234 in 114 games for the Cougars. He then moved back to Brevard County and hit .263 in 121 games with three homers. The Mariners picked him up in the rule five draft and he played in 62 games for Seattle, hitting .217. The next few years he would go between Double-A San Antionio, Triple-A Tacoma, and Seattle. In 2003, he spent 12 games in the majors and hit .200.

Stephen Morales played for the Cougars in 1999 and 2000 as a back-up catcher. In 1999, he hit .271 in 28 games with two homers. In 2000, He hit .219 in 42 games with four homers. He also spent three games up in Triple-A Calgary that year. The next year he played in high Single-A Brevard County and hit .248 in 48 games with four homers. He would make it to Calgary for two games that year also. In 2002, he played in Double-A Portland and hit .262 in 51 games, with a career high five homers. He signed as a free agent in 2003 with the White Sox and played in Triple-A Charlotte and Double-A Birmingham. (Photo by Alan Malamut.)

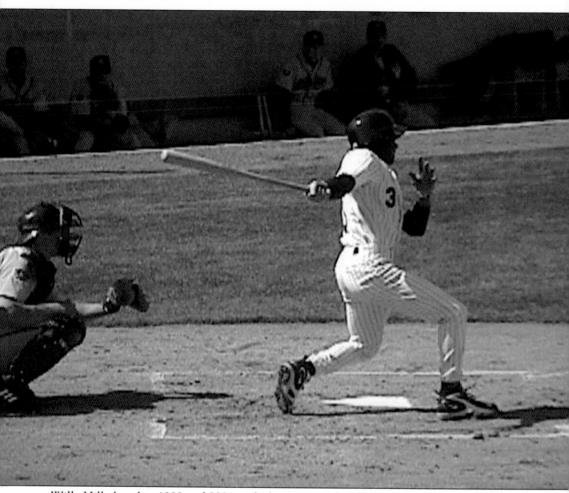

Willy Hill played in 1999 and 2001 with the Cougars. In 1999, he played in 127 games and hit .303 with six triples and 38 steals. He moved on to high Single-A Brevard County the next year and hit .315 in 42 games. He got hurt in 2001, and on rehab playing six games with the Cougars he hit .333. During the season he was released by the Marlins and signed with Atlantic City, where he hit .331 in 37 games. In January of 2003, he signed with Pittsburgh. He hit .277 in Single-A Hickory in 39 games, and then hit .185 in high Single-A Lynchburg in 20 games. (Photo by Alan Malamut.)

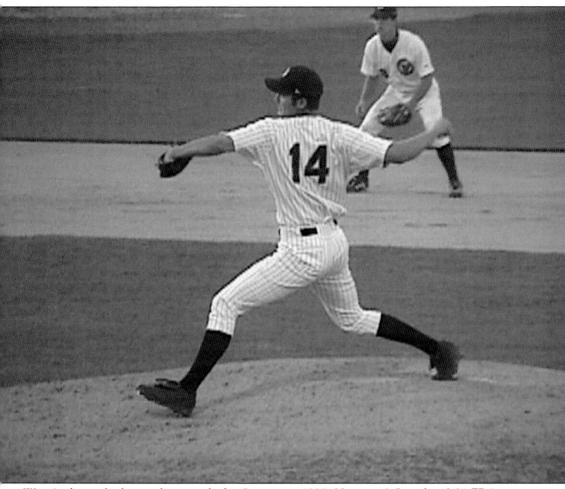

Wes Anderson had a good year with the Cougars in 1999. He went 9-5, with a 3.21 ERA in 23 games, and pitched two complete games. After that, he spent two seasons in high Single-A Brevard County, going a combined 7-15 in 30 games. Then his shoulder/arm gave out on him and he bounced around the rookie league with the Marlins. He was signed by the Red Sox in 2003 and pitched four games at Lowell of the Gulf Coast League without giving up a run. He was then taken by the Tigers in the rule five draft. He was an all-star pitcher in the Gulf Coast League in 1998. (Photo by Alan Malamut.)

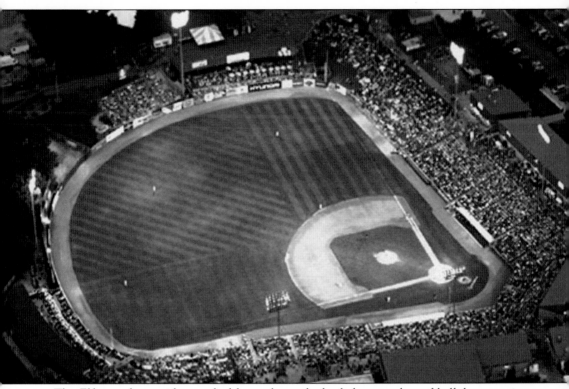

The Elf. seen here with a packed house beneath the lights, saw lots of ballplayers trying to climb that minor league ladder in the late '90s. Jorge Bautista played for the Cougars from 1997 through the 1999 season. In 1997, he played in 20 games and hit .149.The '98 season saw him play in 84 games and hit .261 with seven homers. In 1999 he hit .220 in 61 games and hit three homers. The thing that most people remember is that he is the only position player in recent memory to come into a game as a pitcher and get the win.

Blaine Neal pitched for the Cougars in 1999 and went 4-2, 2.32 in 26 games with six saves., After that he went to high Single-A Brevard County and went 2-3, with a 2.15 ERA and 11 saves. He pitched in Double-A Portland in 2001, going 2-3, with a 2.36 ERA and 21 saves. Neal made his major league debut in 2001, playing in four games and compiling a 6.75 ERA. He went to Triple-A Calgary to start out the 2002 season and posted a 2.90 ERA and eleven saves. He would get back to Florida that year for 32 games, and again the next two seasons.

Drew Niles came to Kane County off the campus of Bowling Green University in 1998. He played in 26 games and hit .276. He also spent 16 games in Triple-A Charlotte that year, hitting .265 and knocking first professional homer. The Next year he went from high Single-A Brevard County to short season Utica to Double-A Portland. Niles found himself back in Kane County in 2000, where he hit .175 in 14 games on rehab. He then went to Portland and Brevard County. He spent the '01 and '02 season in Portland. The 2003 season he spent in Double-A Carolina, hitting .262 in 118 games with three homers.

Kevin Olsen pitched ten games for the Cougars in 1999 and went 5-2 with a 3.38 ERA. He got to the majors with the Marlins in 2001, and in four games earned an ERA of 1.20. In 17 games in Florida in '02, he was 0-5 with a 4.53 ERA. That got him a trip to Triple-A Calgary to finish the season. He pitched for Triple-A Albuquerque in 2003 going 2-1 in seven games. Olsen made it back to the Marlins but posted an ERA of 12.75 in seven games.

Six

2001–2002

The 2001 Cougars would be the best team that has ever played in Kane County, based solely on the fact that they are the only one to ever win a championship. That withstanding, they also had one of the most talented teams to ever take the field at Elfstrom Stadium. They were the first team in Kane County history to ever clinch a playoff spot in the first half. They had the best record in the league, by three games over Wisconsin, and they went a perfect 5-0 in the playoffs. Unfortunately, those playoffs only went five games because of the terrorist attacks on September 11, 2001.

The talent level was great. Chip Ambres, Miguel Cabrera, Matt DeMarco, Adrian Gonzalez, Kevin Hooper, Jim Kavourias, Pat Magness, Will Smith, Josh Willingham, and Josh Wilson all played the field. On the mound were Denny Bautista, Ramon Castillo, Michael Flannery, Rob Henkel, Hansel Izquierdo, Chris Key, Mike McNutt, Randy Messenger, Marc Sauer, Steve Sawyer, and Brandon Sloan.

Kane County was third in the league in hitting, in the middle of the pack in pitching, and second in the league in fielding. Adrian Gonzalez, Miguel Cabrera, Will Smith, and Jim Kavourias all made the post season all-star team. Gonzalez was named most valuable player and prospect of the year. Russ Morman was named manager of the year. Gonzalez was ranked the top prospect in the league. Cabrera was ranked ninth. Will Smith was ranked twelfth.

Opening Day went 10 innings, with the Cougars winning 7-6, against Peoria on April 5. In the top of the tenth the Chiefs had runners on first and second with only one out. Cougar pitcher Randy Messenger got the next two Chiefs to ground out to end the inning. With one out in the bottom of the inning, Chip Ambres hit a solo homer to win the game.

Will Smith hit three homers against the Peoria Chiefs on April 7. Two of his homers were helped by a severe wind blowing out towards right field. The Cougars lost the game, 13-11, as the wind made all the difference in the game. Adrian Gonzalez and Josh Willingham also homered.

Jim Kavourias hit for the cycle on May 9, at Peoria, in a Cougars 15-5 win. He hit a first-inning two-run homer off of Josh Axelson. He scored four runs and also walked once. In that game Josh Wilson hit an eighth-inning grand slam to center.

The Cougars would score four times in the bottom of the ninth to come back and win, 8-7, against West Michigan on May 15. The Whitecaps scored five runs in the seventh to erase a three to one lead for the Cougars. Ronnie Merrill had the big blow as he hit a three-run homer off Chris Key. In the ninth, a catcher's interference call and an error on the pitcher helped the Cougars to a win. Two walks and three singles also didn't hurt.

A June 16 game against the Fort Wayne Wizards drew a new single game attendance record for the Midwest League, as 14,304 fans would crowd into Elfstrom Stadium. The Cougars won the game, 7-6, with three runs in the eighth, and then held off the Wizards in the ninth to the pleasure of all those fans.

The South Bend Silver Hawks would take the Cougars to the bottom the ninth in a scoreless game on July 25, at Elfstrom. The Cougars won the game, 1-0. Chip Ambres led off the inning with a single to center, then moved up to second on a wild pitch. One out later, the Hawks made a pitching change. Will Smith reached on a grounder that went through the first baseman's legs, allowing Ambres to advance to third. Adrian Gonzalez then singled to center to score Ambres to win the game.

On August 17, 2001, the Cougars set a new club record for wins in a season with number 80, and home wins with 45. The Cougars won in the ninth, on a two-out Jim Kavourias two-run homer to get them the 5-3 win. The homer hit off the top of the video board in left center field.

The 2002 season was among the most frustrating in Cougars history. They broke a string of three years in the playoffs, by losing on the second to last day, when they needed a win. The Cougars ended up being eleven games below break even. Their hitting was ranked 13th in the league. Their pitching was eleventh. The fielding was, surprisingly, third best. Jason Stokes won the batting title. Dontrelle Willis won the ERA title. Stokes was a post season all-star and Midwest league MVP; Dontrelle Willis was also a post season all-star. Stokes broke the Cougars single season home run title and led the league with 27 homers. He also led in intentional walks with 15 and slugging percentage. Phil Akens led the league in losses with 15, and hits allowed with 180. Ronald Belizario led the league in hit batsman.

Despite the poor showing in the win-loss record, the Cougars had a little talent. Charlie Frazier, Angel Molina, Rex Rundgren, Jason Stokes, and Michael Tucker would lead the way offensively. Jon Asahina, Ronald Belizario, Kevin Cave, Jeff Fulchino, Lincoln Holdzkom, Nick Ungs, and Dontrelle Willis were the bright lights on the mound.

The Cougars won in the ninth inning against Cedar Rapids on April 11. The score was 2-1 Kernels going into the inning. Charlie Frazier hit a two-out solo shot to tie the game at two. Michael Tucker then walked, Winton Zapay singled to right, and Kernel pitcher Mark O'Sullivan balked home Tucker to give the Cougars the lead.

More late-inning heroics, this time against Wisconsin, occurred on April 13. The Cougars were down, 5-4, going into the bottom of the ninth. Dontrelle Willis had pitched seven innings, giving up three hits and one unearned run. Scott Hicks led off the inning with a double to center. Hunter Wyant then hit a two-run homer down the left field line to win the game.

Dontrelle Willis, Tyler Banks, and Kevin Cave combined for a no-hitter against the rival Beloit Snappers on May 1, 2002. The Cougars took the game, 8-0. George Arnott hit a homer and Michael Tucker had two hits. Willis struck out five Snappers in six innings.

Garrett Jones of the Quad City River Bandits scorched Kane County pitchers on July 14, 2002, in a 16-2 loss by the Cougars. He hit four homers—two three-run shots and two solo shots—for eight runs batted in. Three of the homers were off Wes McCrotty, and the fourth off of Tim Schilling.

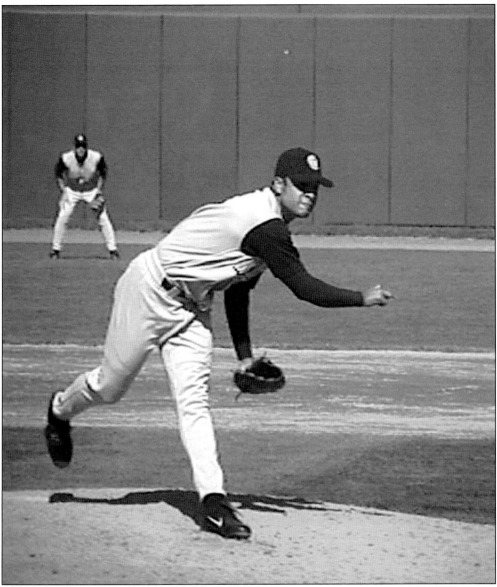

Hansel Izquierdo played for the Cougars in 2001. He went 7-1 with a 1.32 ERA in 24 games. Before that he was released by the Marlins in 1997, signed by the White Sox, and went from high Single-A to Double-A Birmingham. Then he was with Cleveland, in Kinston, before being released and signed within the independent Western League. He signed with the Marlins in 2000. In Kane County he started two games, and he also had two saves, before a mid-season promotion to high Single-A Brevard County where he went 2-0 with a 2.70 ERA in four games. After that he was sent up to Double-A Portland were he went 7-2, 3.81 in 10 games. In 2002, he went from Portland to the Marlins with a 13-game stop off in Triple-A Calgary. In the majors he went 2-0 with a 4.55 ERA in 20 games, including two starts. The Marlins released him in October of 2002, and the Red Sox signed him and sent him to Triple-A Pawtucket, where he lasted four games and had an 11.43 ERA. He was then released and signed with the Expos and sent to Triple-A Edmonton, where he went 2-2 with a 7.41 ERA in 17 games. (Photo by Alan Malamut.)

Matt DeMarco played for the Cougars in 2000 and 2001. He hit .228 in 29 games in 2000, after coming up from the Gulf Coast League. That year he hit his first professional homer with the Cougars. In 2001, he played in 77 games and hit .252. After Kane County he went to high Single-A Jupiter for two seasons. In 2002, he hit .266 in 109 games. In 2003, he hit .240 in 114 games and hit his second and third homers of his pro career. (Photo by Alan Malamut.)

Michael Flannery pitched for the Cougars in 2001. He ended the season as the Cougars closer and registered 16 saves in 53 games. He had a 3-4 record with a 4.79 ERA. He moved up to high Single-A Jupiter the next year and went 2-5 with a 2.21 ERA in 58 games. He had 26 saves and only walked ten hitters. In 2003, he moved up the ladder to Double-A Carolina and went 7-3 with a 2.31 ERA in 56 games. He had 23 saves. In 2004, he played in Triple-A Albuquerque. (Photo by Alan Malamut.)

Miguel Cabrera played for the Cougars as an 18-year-old kid from Venezuela who had spent only one year in America. He played very well, and would be named to the all-star team. He played shortstop for the Cougars. Miguel hit .268 in 110 games, hit seven homers, and had four triples. The next year he went to high Single-A Jupiter and hit .274 in 124 games, hitting nine homers. In 2003, he moved up to Double-A Carolina and hit an amazing .365 in 69 games with ten homers. He was called up to Miami in mid-June from a game in West Tennessee, and hit .268 for the Marlins in 87 games. He also hit 12 homers. Miguel would stay in Miami for the 2004 season and play very well, being named to the National League All-Star Team. (Photos by Alan Malamut.)

Scott Franske was the radio voice of the Cougars from 2000 to 2001. To prove that even radio announcers can move up, he currently works on the Texas Rangers radio broadcast team.

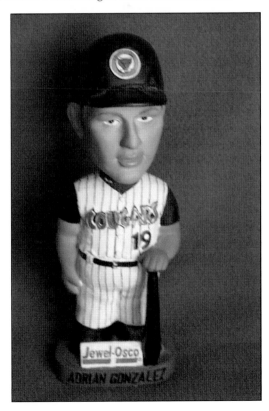

Pictured here is an Adrian Gonzalez bobblehead, a popular souvenir at minor league ballparks throughout the country.

Adrian Gonzalez was the league's most valuable player and an all-star in 2001. He was the Marlins first round pick in 2000, out of high school in California. He hit .312 for the Cougars in 2001 in 127 games. He hit 17 homers and drove in 103 runs at high Single-A Jupiter. After that he went to Double-A Portland where he hit .216 in 138 games, with 17 homers. In 2003, he started the year in Triple-A Albuquerque and hit .216 in 39 games before being sent down to Double-A Carolina. In Carolina he hit .307 in 36 games. Adrian was traded along with Will Smith to the Texas Rangers for Ugueth Urbina. He would be assigned to Frisco and hit .283 in 45 games with three homers. Adrian was named to the 2001 Baseball America low Class-A All-Star Team. (Photos by Alan Malamut.)

Rob Henkel was selected in the third round of the 2000 draft by the Marlins out of California-Los Angeles. He played for the Cougars for one game in 2001, and pitched four innings, giving up six hits and three runs. Two of those runs were earned; he walked one and struck out two. He also pitched in the playoffs once for the Cougars. Rob was sent to high Single-A Jupiter in 2002 and went 8-3 with a 2.51 ERA in 14 games, opponents hitting .206 against him. He was then moved to Double-A Portland where he went 5-4 with a 3.86 ERA in 13 games. In January of 2003, he was traded along with Nate Robertson and Gary Knotts to Detroit for Mark Redmon. Henkel would be assigned to Double-A Erie and go 9-3 with a 3.38 ERA in 16 games. He was injured part of the year and spent most of 2004 on the disabled list with a torn labrum. (Photo by David Malamut.)

This is the ever-popular Ozzie the Cougar bobblehead in his batting practice jersey.

Jim Kavourias (left) poses with Josh Willingham . Kavourias, who is a slugger, played right field for the Cougars in 2001. In 2000, he hit .320 with seven homers for short season Utica, with a slugging percentage of .520 and on-base average of .433 in 15 games. In 2001, he played for Kane County and hit .261 in 120 games. He hit 23 homers and 30 doubles along with four triples. He drove in 88 runs and had eleven steals. He unfortunately struck out 126 times. Jim was an all-star while with the Cougars. He then spent two seasons in high Single-A Jupiter, where his best year was 2003, hitting .247 in 108 games with 20 homers. He was injured much of 2004, but was able to participate in the Olympic Games for his home country of Greece. (Photo by Pam Rasmussen.)

Josh Willingham played for the Cougars in 2001. This photo is of him hitting a homer in Quad City in late August. He hit .259 with the Cougars in 97 games with seven homers. After the season he was moved from third base to behind the plate by the Marlins. In 2002, he went to high Single-A Jupiter and hit .274 in 107 games with 17 homers. He would spend 2003 in Jupiter and Double-A Carolina with a total of 18 homers. He made his major league debut in 2004 for the Marlins. (Photo by Alan Malamut.)

Michael McNutt played for the Cougars in 2001. He would go 9-5 with a 3.94 ERA in 28 games. He had one complete game and he also had one save. In 2002, he went to high Single-A Jupiter and go 12-8 with a 3.17 ERA in 27 games, including two saves. The 2003 season saw him go to Jupiter again. This time he went 7-4 with a 2.45 ERA in 33 games, one save. He also pitched in Double-A Carolina for a game, going five innings, giving up eight hits and five runs with six strikeouts. Mike pitched in Carolina in 2004. (Photo by Alan Malamut.)

Winton Zapey was a catcher for the Cougars in 2001 and 2002. He had one at-bat in 2001 for them. In 2002, he played in 67 games and hit .246 with three homers. He would move to Jupiter later in the year and hit .136. Winton was later released by the Marlins. (Photo by Pam Rasmussen.)

Brandon Sloan pitched for the Cougars in 2001. He would go 3-4 with a 3.36 ERA in 41 games. He started 13 games, and saved nine. He opened the year as the closer and finished it in the rotation. He would spend the next year in three different places with a combined 3-6 record in 51 games, with 10 saves. In high Single-A Jupiter he went 1-0, with a 1.17 ERA in six games with two saves. In 2003, he was again in Jupiter and went 2-5 with a 5.38 ERA in 41 games with five saves. Brandon was released by the Marlins in January of 2004 and played the 2004 season in the Independent Leagues. (Photo by Alan Malamut.)

Will Smith played for the Cougars in 2001. In 2000, in the Gulf Coast League, he hit .368 in 54 games with two homers. At Kane County he would hit .280 in 125 games with 16 homers and 91 runs batted in. High Single-A Jupiter was his destination in 2002 and he hit .299 in 133 games with 14 homers and 12 triples. The 2003 season saw him in three different places. He started the season in Double-A Carolina and hit .293 in 34 games. He then got hurt and went to Jupiter on rehab and hit .083 in three games. After that, he got traded along with Adrian Gonzalez to the Rangers. He would be assigned to Frisco and hit .200 in 37 games. The next season also saw him in Frisco were he would hit better, but spend some of the time on the disabled list. Will was a Gulf Coast League All-Star in 2000 and a Midwest League All-Star in 2001. (Photo by Alan Malamut.)

Josh Wilson played for the Cougars in 2000 and 2001. In 2000, he hit .269 in 13 games, and hit his first pro homer. He would go down to short season Utica and hit .344 in 66 games with three homers. The next year he survived opening the season 0-31, and hit .285 in 123 games with four homers and five triples. He would spend 2002 in high Single-A Jupiter, hitting .256 in 111 games with a career high eleven homers. He went to Double-A Portland for 12 games and hit .341 with two homers. At Double-A Carolina in 2003, he hit .253 in 118 games with six triples and three homers. (Photo by Alan Malamut.)

Nic Ungs pitched in short season Utica in 2000, and would pitch 61 innings without giving up a walk. He went 3-1 with a 1.62 ERA in 12 games. He had 40 strikeouts. In 2002, he pitched for the Cougars and went 7-7 with a 3.73 ERA in 24 games with 16 starts and one save. He walked 19 hitters. He then moved up to high Single-A Jupiter late in the year and went 1-3 with a 4.34 ERA in four games, walking just four. In 2003, he stayed in Jupiter to go 8-3 with a 1.99 ERA in 18 games, and he pitched his first professional complete game. He walked 14 batters in 113 innings. Again he would be moved up late in the year, this time to Double-A Carolina where he went 3-4 with a 3.53 ERA in ten games, giving up eight walks. He pitched in Carolina in 2004. (Photo by Alan Malamut.)

Dontrelle Willis had a great year with the Cougars in 2002. He was drafted in the eighth round by the Cubs. In 2001, he pitched for short season Boise and went 8-2 with a 2.98 ERA in 15 games. He came to the Marlins in the trade that sent Matt Clement to the Cubs. With the Cougars he would go 10-2 with a 1.83 ERA in 19 games, with three complete games. Opponents hit .200 against him. In August he went to high Single-A Jupiter and went 2-0 with a 1.80 ERA in five games. He started the 2003 season in Double-A Carolina and went 4-0 with a 1.49 ERA in six games. It wasn't long before he made the jump to the Marlins for his major league debut. He would go 14-6 with a 3.30 ERA in 27 games, with two complete games. He pitched in the World Series against the Yankees and won National League Rookie of the Year. Dontrelle was a Northwest League All-Star in 2001, a Midwest League All-Star in 2002, and was selected to the Major league All-Star game in 2003. (Photo by Bob Yahr.)

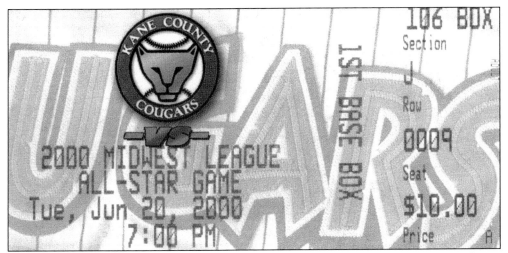

This is the ticket stub from the last time the Cougars hosted the Midwest League All-Star Game, which was in 2000. Matt Padgett was named the MVP of the game.

This is the ticket stub for Game One of the championship series played in South Bend, Indiana, between the Kane County Cougars and the South Bend Silver Hawks. This was the only game played during that championship series because of the tragedy of 9/11. The Cougars won the game, 6-1, and would be crowned champions. Ramon Castillo pitched seven innings of three-hit ball with five strike outs. Francisco Ferrand had three triples before the fifth inning, and scored twice. He drove in three of the runs.

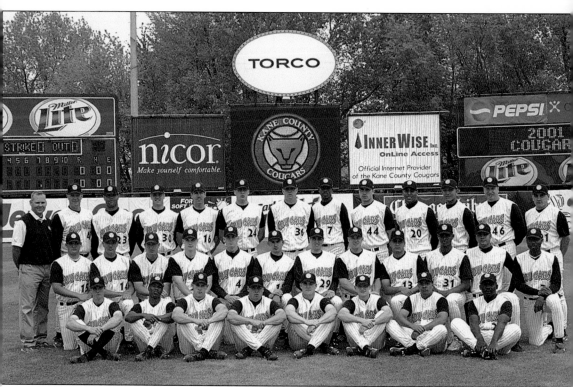

Here are the 2001 Midwest League Champion Kane County Cougars. Plenty of hopeful major leaguers played at Elftrom Stadium in 2001 and 2002. Chip Ambres played for the Cougars from 2000 to 2001. He hit .231 in 84 games in 2000, with seven homers and 26 steals. Chip was a first round pick of the Marlins in the 1998 draft out of high school in Texas. In 2001, he played in 96 games and hit .265 with five homers and eight triples. Unfortunately he would not be able to play in the playoff after breaking his ankle on a slide into second base while playing in Quad City in late August. He then moved on to high Single-A Jupiter for 2002, Double-A Carolina in 2003, and 2004 in Carolina before being released and signed by Boston.

Dennis Anderson played for the Cougars from 2001 to 2002; he was fun to watch because you knew he always gave his all. He would play in 29 games in 2000 and hit .222. In 2001, he played in 78 games and hit .236 with six homers. He started the 2002 season in high Single-A Jupiter and hit .310 in 42 games, but then got sent back to Kane County. He would play in 47 games and hit .247 with four homers. He played in Jupiter and Double-A Carolina after that.

Pat Magness played for the Cougars for 68 games in 2001. He hit .256 with six homers, basically as the designated hitter. He took 53 walks compared to striking out 41 times. He moved up to high Single-A Brevard County and to high Single-A Jupiter and hit .292 in 111 games with 16 homers. In 2003 a .227 average with Double-A Carolina, in 52 games with three homers, got him sent to the Gulf Coast League to recover from injury. In 2004, Pat signed with Cleveland and was assigned to high Single-A Kinston in the Carolina League.

Jason Stokes played for the Cougars in 2002 and won the league MVP, and top prospect awards. He would set the Cougars record for homers in a season while missing most of August with a wrist injury. He hit .341 in 97 games with 27 homers and 75 runs batted in. His slugging percentage was .654 and he had an on-base percentage of .421. In 2003, he went to high Single-A Jupiter and hit .258 with 17 homers and three triples. He also struck out 135 times. In 2004, he played for Double-A Carolina but his wrist would flare up again, making him miss a lot of time. He was Low Class A Player of the Year for 2002. In 2003, he was a Florida State League All-Star. (Photo courtesy Kane County Cougars.)

SEVEN

2003–2004

The 2003 season marked another affiliation change for the Cougars; this is there third affiliation, first the Orioles, than the Marlins, and now the Oakland Athletics.

The team returned to the playoffs after the one year drought. They would make the playoffs, win the first game in Clinton, then lose two straight games at home to get knocked out. The Cougars had the best record and win the regular season league title by three and a half games.

The Cougars were in the middle of the pack in hitting, third in pitching, and led the league in defense. Joe Blanton was sixth in the league in pitching. Drew Dickinson led the league in games started, shutouts, and innings pitched. Joe Blanton led in strikeouts. Brian Stavisky would be named a post season all-star, and Webster Garrison would be named Midwest league Manager of the Year.

The 2003 Cougars had a lot of talent. Offensively they had John Baker, Brant Colamarino, Nelson Cruz, Andre Ethier, Francis Gomez, Dustin Majewski, Marcus McBeth, and Brian Stavisky. On the mound they had Joe Blanton, Drew Dickisnon, Chris Dunwell, Jairo Garcia, Shawn Kohn, Shane Komine, Shawn Kohn, Matt Lynch, Jeff Muessig, Bill Murphy, Steve Obenchain, Chris Shank, Edwardo Sierra, and Brad Sullivan. Several of these players were promoted to either high Single-A Modesto or Double-A Midland during the season.

The first time an opponent scored on the Cougars was in the fourth game of the season, which was after 24 innings, all against the Clinton Lumberkings in back-to-back double headers. Two days later, after a rainout, the Cougars would play another double header, this one against Burlington. This was a very long and very cold day. The first game went 13 innings and the Cougars won, 3-2. Brant Colamarino singled home J.P. Schmidt to win it. The second game would go 15 innings and the Cougars won this one, 2-1. This time Colamarino singled home Kory Wayment. In all there was almost seven and a half hours of baseball, in sub-freezing April temps by the time it ended at 11:30 P.M.

Christain Gonzalez pitched a complete game five-hitter against Cedar Rapids on May 27, leading the Cougars to a 1-0 win. Marcus McBeth drove home Jason Basil for the sole run. Gonzalez struck out three in the game.

Bill Murphy threw a no-hitter on June 10, 2003, at West Michigan. He walked one and struck out seven Whitecaps. The Cougars won, 6-0. John Baker and Brant Colamarino went deep.

A month later, Blanton threw a complete game six hitter at Clinton on July 10. The Cougars won, 7-0. Blanton had 11 strikeouts. Nick Rogers had a homer.

In 2004, the Cougars would reach the championship round again, this time making it all the way to the final, winner-take-all game, before they would run out of gas. The Cougars again had the best record in the league, this time by six and a half games over Lansing. They won both halves of the season in their division. The Cougars ended the season in the middle of the pack in hitting, pitching, and fielding. Brian Snyder and Vasili Spanos were fifth and sixth in the league in hitting. Steve Bondurant led the league in pitching, with Brad Knox not that far behind in second. Brad Knox and Steve Bondurant were named to the post season all-star team. Dave Joppie would be named manager of the year. Brian Ingram led the league in walks. Dan Fyvie led in the league in games. Chris Dunwell led in hits allowed. Brad Knox led in strikeouts.

The Cougars had a lot of talent on the field. In the batters box they had Luke Appert, David Castillo, Brian Ingram, Dustin Majewski, Danny Putnam, Brian Snyder, and Vasili Spanos. On the mound Steve Bondurant, Dallas Braden, Jose Corchado, Chris Dunwell, Dan Fyvie, Jairo Garcia, Brad Knox, Mike McGirr, Trent Peterson, Huston Street and Jason Windsor.

Eddie Kim provided one of the most memorable endings to a game in memory. On April 14, 2004, the Cougars needed a grand slam to win the game in the bottom of the ninth against The Swing of Quad Cities. With one out Ingram walked. Appert then reached on a bouncer up the middle. Castillo walked to load the bases. Kim then took the fourth pitch he saw from a new Swing pitcher over the deck for a game-winning grand slam homer. The Cougars won the game, 7-6.

The Cougars would beat the Battle Creek Yankees 20-0 on April 29. Steve Bondurant had a no-hitter going into the ninth inning, but was removed with one out. He walked four and struck out 14. Manny Rodriguez would get the final two outs. Vasili Spanos hit a two-run homer. The next day the Cougars would win, 10-0, over Battle Creek with Brad Knox pitching well in seven innings. It got scary during the third game of the series as the Cougars won, 7-1. Chris Dunwell pitched well. You knew it had to end; the Cougars would get only three hits in the final game of the series and lose, 1-0, to the Yanks.

The Cougars lost the first game of the playoffs to the Peoria Chiefs on a twelfth-inning one-out solo home run by Anthony Monegan. The Cougars took the next two games at home. In the second game Brad Knox pitched well in six innings. Dallas Braden pitched seven good innings in the third game.

The second round saw the Cougars go to Clinton where they would win the first game, 18-4. Vasili Spanos and Rich Robnett (who had just been called up from short season Vancouver) both hit homers. It was Robnett's first Cougar game. The bullpen pulled them to a win in the second game and a sweep of the series.

Hosting the first two games against the West Michigan Whitecaps for the title, the Cougars won the first game, 10-5. Luke Appert hit a three-run homer. A two-out two-run homer in the seventh inning gave the Whitecaps the second game, 2-1. The Cougars lost the third game despite a good pitching performance by Dallas Braden.

The fourth game was fun to watch. It took five and a half hours and 16 innings, and if the Cougars would have lost, the season would have been over. In the fourteenth inning, Vasili Spanos hit a homer and David Castillo drove home Dan Putnam to put the Cougars up by two. Danilo Sanchez scored on a Garth McKinney double. Kody Kirland scored on a Jason Knoedler sacrifice fly to tie the game. In the sixteenth, David Castillo hit one out to left center field to put the Cougars back up by two runs. Jared Trout got out of a jam in the bottom of the inning, with runners on, to win the game.

The next day the Cougars lost, 4-2, and the Whitecaps would be crowned Midwest League Champions. Trent Peterson pitched well in the game.

Jason Windsor was the 2004 College World Series Most Valuable Player for Cal State-Fullerton. He went to short season Vancouver out of college and pitched in four games with one save. At Kane County he pitched in nine games out of the bullpen and went 1-0, with a 2.77 ERA and three saves. He pitched 13 innings and had 13 strikeouts, giving up only eleven hits. (Photo by Bob Yahr.)

Nelson Cruz signed on as a non-drafted free agent with the Mets in 1998. The Mets would trade him to Oakland in 2000. In 2002, he played at short season Vancouver and hit .276 with four homers in 63 games. He played at Kane County in 2003 and hit .238 with 20 homers in 119 games in right field. He moved to high Single-A Modesto in 2004, and continued to hit; he flew through Double-A Midland and went to Triple-A Sacramento for a while. (Photo by Alan Malamut.)

Dallas Braden came out of the draft in 2004 and pitched well for the Cougars. He went 2-1 with a 4.70 ERA in five games. He went to short season Vancouver first and went 2-0 with a 2.33 ERA in eight games with two saves. (Photo by Alan Malamut.)

David Castillo played catcher with the Cougars in 2004. In 2003, he played in short season Vancouver and hit .257 in 51 games with one homer. With the Cougars he played in 111 games and hit .246 with nine homers. (Photo by Bob Yahr.)

Trent Peterson pitched for the Cougars in 2004. He pitched for short season Vancouver in 2003, going 3-4 with a 3.25 ERA in 14 games with one save. After some time in extended spring training he would be assigned to the Cougars in 2004. He went 8-5 with a 3.42 ERA in 21 games. Trent pitched one complete game. (Photo by Alan Malamut.)

Francis Gomez played second base for the Cougars. He is a natural shortstop. In 2003, he was with the Cougars and hit .265 in 128 games with five homers. He would go straight up to Double-A Midland and play second, short and third—and do OK at each position. He also spent a couple games at Triple-A Sacramento. (Photo by Alan Malamut.)

Chris Shank spent 12 games in Kane County in 2003. He went 5-0 with a 2.86 ERA. He was moved to high Single-A Modesto and went 1-2 with a 4.14 ERA in 26 games out of the pen. Again in 2004, he spent his season in Modesto and went 6-5 with a 3.99 ERA in 49 games. (Photo by Alan Malamut.)

J.R. Pickens (left), and Eddie Kim (right) are having fun with fans at the ballpark. Pickens pitched for the Cougars in 2004 and went 6-2, with a 3.44 ERA and 5 saves in 54 games. He played in short season Vancouver in 2002 and 03. In 2002, he spent one game there and got a save with two innings of work. In 2003, he spent 23 games up north. He went 6-2, with a 3.07 ERA and five saves. He also started four games. Kim played first base for the Cougars in 2004. It is hard to imagine someone bigger than Kim. He is listed at 6-foot-3, 260 pounds and its all muscle. He hit .254 in 113 games for the Cougars with ten homers. In 2003, he played at short season Vancouver and hit .305 in 65 games with four homers. (Photo by Bob Yahr.)

Luke Appert played second base for the Cougars in 2004 and hit towards the top of the order. He hit .274 in 128 games with 13 homers. He also had three triples and 28 doubles. Luke walked 80 times and struck out only 63. In 2003, he was in short season Vancouver and hit .193 in 58 games with one homer. He did walk 49 times with only 29 strikeouts. (Photo by Alan Malamut.)

John Baker caught for the Cougars in 2003. He played in short season Vancouver in 2002 and hit .235 in 39 games. With the Cougars he played in 82 games and hit .309 with six homers. He was later promoted to Double-A Midland, playing in 43 games and hitting .240. He would again be in Midland in 2004, when he hit .280 in 117 games with 15 homers. (Photo by Alan Malamut.)

Joe Blanton, who made yet another popular bobblehead, had a good year for the Cougars in 2003. In 2002, he pitched for short season Vancouver and high Single-A Modesto and went a combined 1-2 in six games. At Kane County he went 8-7 with a 2.57 ERA in 21 games. He had two complete games, and even though he was gone from the Cougars in August he still led the league in strikeouts. He went to Midland and went 3-1, with a 1.26 ERA in seven games. He had a complete game and a save. In 2004, he went to Triple-A Sacramento and went 11-8, with a 4.19 ERA in 28 games with one complete game. Joe made his major league debut with the Athletics and played in three games. (Photo by Alan Malamut.)

Brant Colamrino (left) poses with Eddie Williams. Brant Colamarino played first base for the Cougars in 2003. He hit .259 in short season Vancouver in 2002 with six homers. In 2003, he was a Cougar and hit .259 in 133 games with 19 homers and 80 runs batted in. In 2004, he played in high Single-A Modesto and hit .355 in 50 games with eleven homers. Brant then got moved up to Double-A Midland and continued to hit well. He played in 78 games and hit .272 with eight homers and 50 runs batted in. Eddie Williams played for Cedar Rapids in 1985, and was named the Midwest League Most Valuable Player. He went on to play for Cincinnati, Chicago (AL), and San Diego in the majors. Eddie was the hitting coach for the Cougars in 2003. This is all we saw of his uniform top for most of the year. (Photo by Bob Yahr.)

Seen here are Chris Dunwell (right), Chris Mowday (center), and Drew Dickinson (left). Dunwell pitched for the Cougars in 2003 and 2004. In '03 he pitched in 30 games and went 4-0 with a 3.21 ERA and two saves out of the pen. In '04 he was in the rotation and went 11-8 with a 4.41 in 28 games. He had an unbeaten streak of ten in a row as a Cougars at one point in the '04 season. Chris Mowday pitched for the Cougars in 2003 and went 4-3 with a 6.49 ERA in 21 games. He pitched for high Single-A Daytona in the Cubs organization in 2004. Drew Dickinson pitched for the University of Illinois, and then he went to short season Vancouver in 2002, 4-0 with a 2.06 ERA in eleven games. That earned him a promotion to low A Visalia where he went 1-1 with a 3.38 ERA. In 2003, he pitched for the Cougars and went 11-11 with a 3.15 ERA in 28 games. He had five complete games. He was among the best pitchers for the Cougars in 2004. (Photo by Bob Yahr.)

Dan Fyvie came out of the Cougars bullpen and pitched well. He went 4-1, with a 3.59 ERA in a league-leading 59 games. He had five saves and opponents hit .239 off him. Dan started out with the Arizona League Athletics in 2002 and went 3-1, earning a 2.92 ERA in 19 games with two saves. In 2003, he went to short season Vancouver and recorded a record of 4-2 with a 2.45 ERA in 26 games with four saves. (Photo by Alan Malamut.)

Brian Ingram played shortstop for the Cougars in 2004. He played in short season Vancouver in 2003 and hit .221 in 43 games. In Kane County he hit .229 in 126 games but he led the league in walks with 84. He also had five triples and four homers. (Photo by Bob Yahr.)

Huston Street pitched very well in his short time in Kane County. He pitched in nine games, and had a 0-1 record with a 1.69 ERA. He had four saves. He spent time in Double-A Midland with a record of 1-0, posting a 1.35 ERA in ten games with three saves. Street also went to Triple-A Sacramento and in two games had one save. He pitched in the College World Series in 2004. (Photo by Alan Malamut.)

Brad Knox pitched very well for the Cougars in 2004. He went 14-5 with a 2.59 ERA in 26 games. In 16 innings he had 141 hits allowed and 174 strikeouts. The strikeouts led the league. In 2003, he played in short season Vancouver and went 6-3 with a 2.06 ERA in 15 games. Knox was among the best starters for the Cougars in 2004, and the most consistent. (photo by Alan Malamut.)

Dustin Majewski played for the Cougars in 2003 and 2004. In 2003, he started out in short season Vancouver and hit .291 in 46 games with three homers and two triples. He came to the Cougars late in the year and appeared in four games, hitting .167. In 2004, he played for the Cougars again and would hit .274 in 127 games before he hurt his ankle. Majewski hit 12 homers and stole 20 bases. (Photo by Bob Yahr.)

Bill Murphy spent most of the 2003 season in Kane County. In 2002, he went 1-4 with a 4.57 ERA in 13 games at short season Vancouver. As a Cougar he went 7-4 with a 2.25 ERA in 14 games. Murphy would have one complete game, and opponents hit .188 off him. Bill then moved up to Double-A Midland and went 3-3 with a 4.09 ERA in eleven games. He was traded after the season to the Marlins in the trade that brought Mark Redman to Oakland. He pitched at Double-A Carolina for much of the 2004 season. (Photo by Alan Malamut.)

Danny Putnam came to the Cougars from Stanford. He played in short season Vancouver to start out his career after being drafted in the first round of the 2004 draft. In Vancouver he hit .289 in eleven games with two homers. He had 14 walks and eight strikeouts. As a Cougar he would hit .220 with seven homers in 50 games. He also had two triples. (Photo by Alan Malamut.)

Richie Robnett played for the Cougars starting in the second round of the playoffs in 2004. In his first game he would hit a homer, a double, and score four runs. He hit .357 in the seven playoff games. Robnett played most of the season in short season Vancouver. He hit .299 in 43 games with four homers and 36 runs batted in. (Photo by Alan Malamut.)

Brian Snyder played for the Cougars in 2004, after being a first round pick of the Athletics in 2003. He would play in short season Vancouver and hit .253 in 44 games. In 2004, he went to Kane County and hit .311 in 101 games with 13 homers. He was injured most of the second half of the season. (Photo by Alan Malamut.)

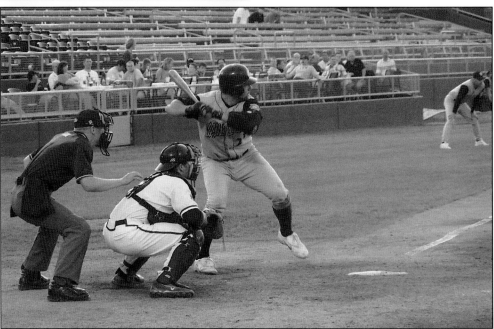

Vasili Spanos played for the Cougars in 2004, was arguably the most valuable player for the cougars. He hit .311 in 97 games with 12 homers and 80 runs batted in. He also played for the Greek Olympic team in the Athens. In 2003, he played for the Arizona League Athletics and hit .278 in five games. (Photo by Alan Malamut.)

Ozzie welcomed several more hopeful young ball players to the Elf in 2003 and 2004. Brian Stavisky played for the University of Notre Dame. In 2003, he came to Kane County to be the everyday designated hitter. He hit .266 in 98 games with six homers. Brian was named to the post season all-star team. In 2004, he played for high Single-A Modesto and had a awesome year. He was named the league MVP after hitting .343 in 130 games with 19 homers and 83 runs batted in. He also had five triples and scored 108 runs.

Steve Bondurant pitched for the Cougars in 2004. He went 14-5 in 21 games with a 2.08 ERA. He had two complete games. Steve pitched 126 innings and had 132 strikeouts, and opponents hit only .200 off him. Bondurant then moved up to Double-A Midland and went 2-3 with a 6.39 ERA in seven games.

Jairo Garcia was a Cougar in 2003 and 2004. He went 0-1 with a 2.55 ERA in 14 games in 2003. He started nine of those games but would go to the pen because of control issues. In 2004, he went 1-0 with an 0.30 ERA in 25 games, earning 16 saves. He next went on to Double-A Midland, Triple-A Sacramento, and his big league debut with the A's.

Shawn Kohn pitched for the Cougars in 2003, going 6-4 with a 2.54 ERA in 45 games. He started four games and had two saves. In 2004, he pitched for both Modesto and Sacramento.

Shane Komine pitched for the Cougars in 2003 and went 6-0 with a 1.82 ERA in eight games, pitching one complete game. He had 50 strikeouts to nine walks. He then went to Midland and struggled. In 2004, he pitched for Midland and went 4-5 with a 4.77 ERA in 17 games before hurting his arm.

Matt Lynch went 4-4 with a 4.53 ERA in 13 games for the Cougars in 2003. In 2004, he pitched for Modesto and went 13-3 with a 3.93 ERA in 27 games.

Marcus McBeth played for the Cougars in 2003 and hit .256 in 68 games with four homers. He played center, has a rifle arm, and can go get the ball. In 2004, he played for Modesto and hit .234 in 99 games with five homers and four triples.

Steve Obenchain came to the Cougars only for a while in 2003. He went 3-5 with a 2.57 ERA in eleven games. He started eight of those games. In 2004, he pitched for Modesto, going 3-3 with a 4.76 ERA in 23 games.

Nick Rogers played for the Cougars in 2003 and 2004. He played in 89 games and hit .241 with five homers. In 2004, he played in 94 games and hit .240 with three homers and four triples. He had 14 steals.

Edwardo Sierra was the Cougars closer in 2003 after Garcia was injured. He went 3-5 with a 2.09 ERA in 51 games, earning 17 saves. He would get traded to the Yankees in late 2003. Edwardo pitched for Tampa in the Florida State league and was an all star.

Brad Sullivan was the Athletics first round pick in 2004. He would pitch for the Cougars shortly after signing; he went 1-0, earning a 3.18 ERA in six games. In 2004, he struggled in Modesto, going 8-11 with a 4.65 ERA in 27 games.

John Suomi played for the Cougars in 2003 and hit .257 in 69 games as a back up catcher. In 2004, he had a breakout season in Modesto. He hit .297 with 12 homers in 134 games. He hurt his knee in a home plate collision in the playoffs and will miss much of the 2005 season.

Cougars who have played in the majors

# Date	Name (Position)	Major League Year	Team
1. 4/14/93	Brad Pennington (p)	1991	Baltimore
2. 4/4/94	Hector Carrasco (p)	1993	Cincinnati
3. 5/6/94	Charles Johnson (c)	1993	Florida
4. 5/31/94	Jose Mercedes (p)	1992	Milwaukee
5. 6/2/94	Scott Klingenbeck (p)	1992	Baltimore
6. 5/2/95	Vaughn Eshleman (p)	1991	Boston
7. 5/6/95	Greg Zaun (c)	1991	Baltimore
8. 6/2/95	Curtis Goodwin (of)	1992	Baltimore
9. 7/7/95	Rick Krivda (p)	1992	Baltimore
10. 7/9/95	Joe Borowski (p)	1991	Baltimore
11. 8/12/95	Jim Dedrick (p)	1991	Baltimore
12. 8/28/95	Marc Valdez (p)	1994	Florida
13. 9/14/95	Jimmy Haynes (p)	1992	Baltimore
14. 9/18/95	Alex Ochoa (of)	1992	New York (NL)
15. 5/10/96	Ralph Milliard (2b)	1994	Florida
16. 5/10/96	Edgar Renteria (ss)	1993	Florida
17. 5/26/96	Bobby Chouinard (p)	1991-92	Oakland
18. 7/26/96	Billy McMillon (of)	1994	Florida
19. 8/8/96	Luis Castillo (2b)	1995	Florida
20. 8/9/96	Felix Heredia (p)	1994	Florida
21. 9/24/96	Josh Booty (3b)	1995-96	Florida
22. 9/29/96	Andy Larkin (p)	1994	Florida
23. 4/2/97	Tom Martin (p)	1991	Houston
24. 4/3/97	Will Cunnane (p)	1994	San Diego
25. 4/5/97	Tony Saunders (p)	1993	Florida
26. 5/10/97	Todd Dunwoody (of)	1994-95	Florida
27. 6/17/97	Antonio Alfonseca (p)	1994	Florida
28. 7/4/97	Matt Whisenant (p)	1993	Florida
29. 7/11/97	Mark Kotsay (of)	1996	Florida
30. 3/31/98	Ryan Jackson (of)	1995	Florida
31. 4/1/98	Victor Darensbourg (p)	1993	Florida
32. 4/1/98	Gabe Gonzalez (p)	1995	Florida
33. 4/2/98	Dave Berg (3b)	1994	Florida
34. 4/4/98	Brian Meadows (p)	1995	Florida
35. 4/11/98	Kevin Millar (1b)	1994	Florida
36. 4/20/98	John Roskos (c)	1995	Florida
37. 5/11/98	Randy Winn (of)	1996	Tampa Bay
38. 5/14/98	Scott McClain (3b)	1991-92	Tampa Bay
39. 5/23/98	Ryan Dempster (p)	1996	Florida
40. 5/31/98	Mike Redmond (c)	1993-94	Florida
41. 7/3/98	Bryan Ward (p)	1994	Chicago (AL)
42. 8/25/98	Alex Gonzalez (ss)	1996	Florida
43. 9/23/98	Michael Duvall (p)	1996	Tampa Bay
44. 5/18/99	Roosevelt Brown (of)	1996-97	Chicago (NL)
45. 5/20/99	Brent Billingsley (p)	1997	Florida
46. 7/5/99	Amaury Garcia (2b-3b)	1995-96	Florida
47. 7/16/99	Chris Clapinski (2b-3b)	1993	Florida
48. 7/26/99	Hector Almonte (p)	1997-98	Florida
49. 8/17/99	A.J. Burnett (p)	1998	Florida
50. 9/8/99	Michael Tejera (p)	1998	Florida
51. 9/10/99	Julio Ramirez (of)	1997	Florida
52. 7/29/00	B.J. Waszgis (c)	1992	Texas
53. 8/31/00	Ross Gload (1b)	1998	Chicago (NL)
54. 9/5/00	Nate Rolison (1b)	1996	Florida
55. 7/6/01	Scott Podsednik (of)	1997	Seattle
56. 7/28/01	Gary Knotts (p)	1997-98	Florida
57. 9/3/01	Blaine Neal (p)	1999	Florida
58. 9/4/01	Josh Beckett (p)	2000	Florida
59. 9/7/01	Kevin Olsen (p)	1999	Florida
60. 4/3/02	Luis Ugueto (ss)	1999	Seattle
61. 4/21/02	Hansel Izquierdo (p)	2000	Florida
62. 6/4/02	Jason Pearson (p)	1998	San Diego
63. 9/7/02	Nate Robertson (p)	1999-2000	Florida
64. 4/26/03	Claudio Vargas (p)	1999	Montreal
65. 5/9/03	Dontrelle Willis (p)	2002	Florida
66. 6/21/03	Miguel Cabrera (ss)	2001	Florida
67. 4/18/04	Adrian Gonzalez (1b)	2001	Texas
68. 5/25/04	Denny Bautista (p)	2001	Baltimore
69. 6/2/04	Matt Treanor (c)	1999, 01	Florida
70. 6/28/04	Chris Aguila (of)	1999	Florida
71. 7/6/04	Josh Willingham (3b)	2001	Florida
72. 7/9/04	Matt Erickson (3b)	1998	Milwaukee
73. 8/9/04	Jairo Garcia (p)	2003-04	Oakland
74. 9/21/04	Joe Blanton (p)	2003	Oakland